prolog

THE PARTICIPANT BECOMES THE 'STRUCTURAL
NUCLEUS' OF THE WORK, THE EXISTENTIAL
UNFOLDING OF HIS INCORPOREAL SPACE. [1]

HÉLIO OITICICA ABOUT HIS WORK "PARANGOLÉS", 1965

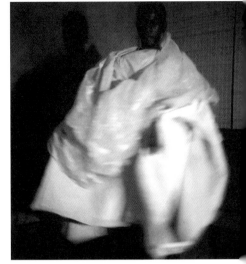

*Jerônimo wearing Parangolé P7 Cape 4 - "Lygia
Clark" - Hélio Oiticica, 1964-65*

elasticity of space
a prologue by Gabi Schillig

from representational
to real space

The emergence of kinetic art can be considered as the most specific product of tendencies of delimitation during Modernism. It was kinetic art that finally dissolved the boundaries between object and spectator. Artists of that time, like Naum Gabo or László Moholy-Nagy generated an art of the real-space, operated in real time with real forces, that entailed an endless transformation of expression in which the spectators could immerse themselves. In his book *Vom Material zur Architektur* Moholy-Nagy describes in 1929 the further development of sculpture by adding time as a fourth dimension and therefore its abstraction through movement: the mass tends to dematerialize through movement. Through movement the sculpture evolves into an appearance of virtual volumetric relations.

He describes the transformation from material - from static to kinetic - as virtual volumes:

"We must therefore put in the place of the static principle of classical art the dynamic principle of universal life. Stated practically: instead of static material construction (material and form relations), dynamic construction (vital constructivism and force relations) must be evolved, in which the material is employed as the carrier of forces. Extending the unit of construction, a dynamic constructive system of force is attained, whereby man, hitherto merely receptive in his observation of works of art, experiences a heightening of his own faculties, and becomes himself an active partner with the forces unfolding in himself." [3]

Moholy-Nagy already anticipated the interaction of the spectator with his environment. The integration into an artistic process results in an extension of body in time and space that at the same time is open for all materials and media. This performative process breaks the boundary between traditionally divided units and enables the communication between object and spectator and the dissolution of spatial boundaries which originally separated both of them.

Movement and architecture usually appear in direct opposition - as dynamics and stasis - whereas architecture is in general considered to be static in contrast to the moving human body. According to the French philosopher and phenomenologist Maurice Merleau-Ponty the body is not a static component of space, but instead he considers the body *'le corps propre'* as the expression of an intermediate state between subject and object, as a mediating entity between mind and body. In this regard he describes a concept of spatiality in which the *'living body'* [2] becomes the centre of focus. In his thoughts he addresses the issue of an interacting body-subject that is characterized by a corporal consciousness. The moving and interacting body stands in opposition to the humanist practice whereby the body was considered as fixed and static. Movement generates a non-determined concept of space where spatial and bodily boundaries are constantly blurring.

the interactive
'dance in my experience' [4)]
the work of Hélio Oiticica

Specifically Brazilian artists of the neo-concrete movement during the 1950s and 1960s re-evaluated aesthetic principles of Modernism in their works. They questioned representational tendencies in art, by establishing new relations between the inner and outer space of body. The notion of visuality was eclipsed, as Lygia Clark and Hélio Oiticica concentrated in their work on the body and explored tactile space through haptic, auditive, olfactory and kinetic propositions.

Most notably Hélio Oiticica (1937-1980) worked with ephemeral materials and created multi-sensorial objects, in whose artistic development processes the spectator was involved. His works became more and more interactive as moved away from his object-based works, towards projects where the body became centre of the work and where the participation of the user became his central focus.

Beside his first object-based works, e.g. *Spatial Relief* - which were wooden colored geometrical structures hanging from the ceiling that could only be fully perceived through the spectators movement around the object - he worked on the so-called *Trans-objects* (*Bólides*) that could be experienced by using multiple senses and which would only be activated by their exploration through the user. Between 1964 and 1968 Oiticica designed a series of textile structures, the *Parangolés*. In 1965 he invited people from the favelas, to interact with those structures during an exhibition opening at the Museu de Arte Moderna in Rio de Janeiro – which was a quite radical intervention during an official institutional event. The *Parangolés* communicated through the user's experience and emphasized the dynamics of life, in opposition to attempts to see the world as something systematic and static. Oiticica, who was at the same time artist, performer and thinker, placed his work between the avant-garde, Brasilian pop-culture and in the context of the Brasilian reality of underdevelopment and political radicalism in the 1960s. Through his work he succeeded in reflecting changes in art and society and articulated questions on issues of freedom in contemporary society and culture.

The dissolution of the objects boundaries, is simultaneously accompanied by a redefinition of the role of the subject. The mobilization of the spectator reaches a new quality: empathy is not only achieved by the visual sense, but by touch – thus the interaction of the body with the material. Space realizes itself in action and imagination of the spectator who has become a participant and user, without whose physical participation the work would not be entirely realized. Space itself possesses an inventive strength and emerges as something that is never definite or completed. Attributed functions can only be achieved, if the spectator becomes active – which leads to a critical self-reflection of the artist; his/her sole role as creator is relativized. These kinetic models and the resulting dissolution of object and spatial boundaries can be identified as early concepts for virtual space as it emerged later on in the 20th century.

B 03 Bólide caixa 03 „Africana" e „Addendum" - Hélio Oiticica, 1963

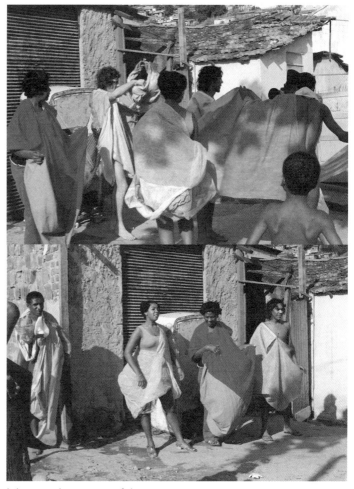

Hélio Oiticica - Group of people with Parangolés during the shooting of the film HO, by Ivan Cardoso, 1979
Photos: Andreas Valentin

Later in the 1960s, Oiticica expanded the spatial properties of the *Parangolés*, and created two larger spatial installations that he described as experiences: *Tropicália* and *Eden* referred to a spatial context through situating them within natural elements such as water, plants and sand. Oiticica invited people to step barefoot into these environments and to inhabit them – establishing new relationships between surroundings and bodies; these '*environments*' transformed increasingly into immaterial spaces. Oiticica created rather temporary situations that enabled a more open and physically related experience of space.

Artists such as Lygia Clark and Hélio Oiticica generated a unique interactive vocabulary which they explored through their work – a vocabulary that is highly relevant for architectural production.

the performative
performative constructs beyond geometry

Within the scope of a four-day workshop at Aristotle University Thessaloniki individual spatial design strategies were developed by analyzing a certain textile technique or garment and its underlying geometrical, spatial appearance. Through abstraction of these systems, by filtering their "ingredients", geometric rules and principles, performative spatial organizations, were enfolded by the participants. Essential to the process was the exploration of materialities, their underlying geometric principles and finally a further systematic development of their spatial and material characteristics. Due to the resulting elasticity of those material constructs, these newly developed systems are open for change and alteration by the human body. The work is dynamic in time and space, rejecting static conditions – exploring spatial aspects beyond pure geometry.

What the spatial models in this book have in common with the kinetic apparatuses of early Modernism and the multi-sensorial objects that Oiticica created in the 60s, is their ability to change, to alter - although they remain clearly defined systems based on certain constructed relationships. Through the ability to change through movement they turn into small imaginative machines for debordering their own space, the space that surrounds them and the space that originally separated them from the spectator. The fact that they are physical objects, constructed out of specific materiality and their interaction with the body, transforms them into sensorial instruments for creating new types of spaces and environments. The soft geometries that emerged during the workshop suggest a space that enables situations beyond geometry, where the object resolves into movement and a state of blurring boundaries. The models anticipate a precursor of virtual space - a virtual space where the body is not suppressed, but for which it becomes the initiator of space.

Public Receptors: Beneath the Skin by Gabi Schillig, New York City, 2009; Van Alen Institute New York

Those changeable, but tectonic structures are open for a process of appropriation through a user, come into interaction with their environment and enable a constant alteration of bodies and spaces. They provide a future prospect towards a new, widened concept of architecture, in which the human body is the operating force and where through the interaction between space and the body spatial boundaries are blurring.

Architecture shifts towards a system of temporary control – an elastic space evolves for the presence of the body.

NOTES
1) Between 1964 and 1968, Oiticica created a series of costumes, the Parangolés, a word that is Brazilian slang for "agitated situation" or "sudden confusion"; Oiticica, "Notes on the Parangolé", 1965 in Hélio Oiticica
2) A term used by Maurice Merleau-Ponty in "Phenomenology of Perception", where he describes his embodied understanding of bodies and their surrounding environment and where he considers the living body to be essential for how we perceive our own existence.
3) László Moholy-Nagy in "The New Vision", 1928
4) Hélio Oiticica, "Dance in my Experience", Diary Entry, 12 November 1965; reprinted in Figueiredo L., Pape L., Salomao: Hélio Oiticica: Aspiro ao Grande Labirinto, Rio de Janeiro, 1986
5) © All images of Hélio Oiticica´s work are courtesy of Projeto Hélio Oiticica, Rio de Janeiro

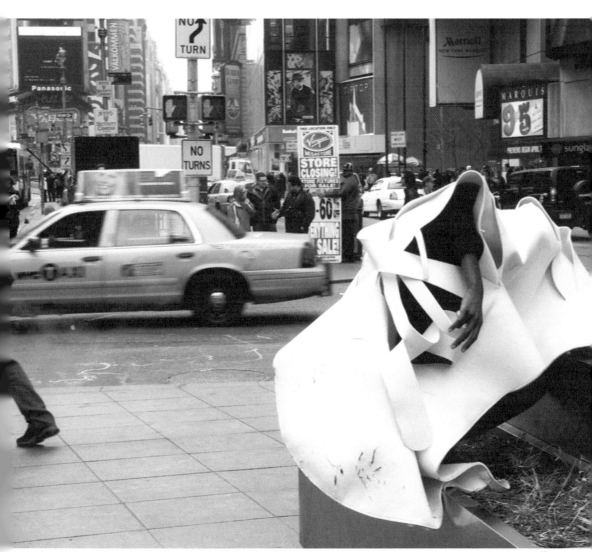

projects

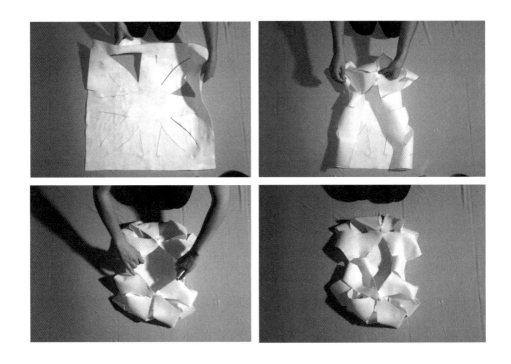

receptive knot

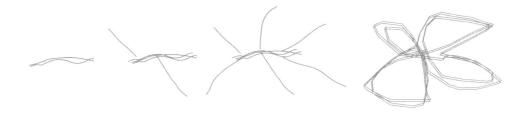

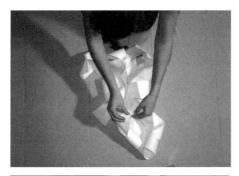

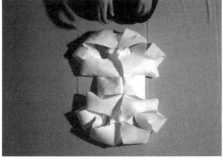

analysis_ knotted dress by Hussein Chalayan

textile techniques_ volumetric folding, sewing
transformation_ three-dimensional folding of a knot
and its multiple connection within a volumetric field
materiality_ felt
effects_ elasticity, softness, changeability

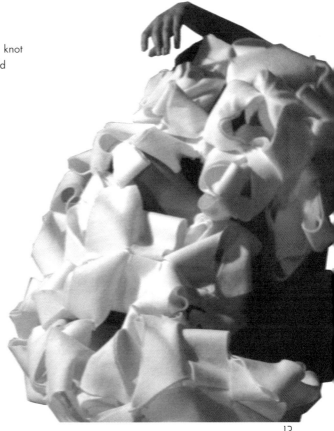

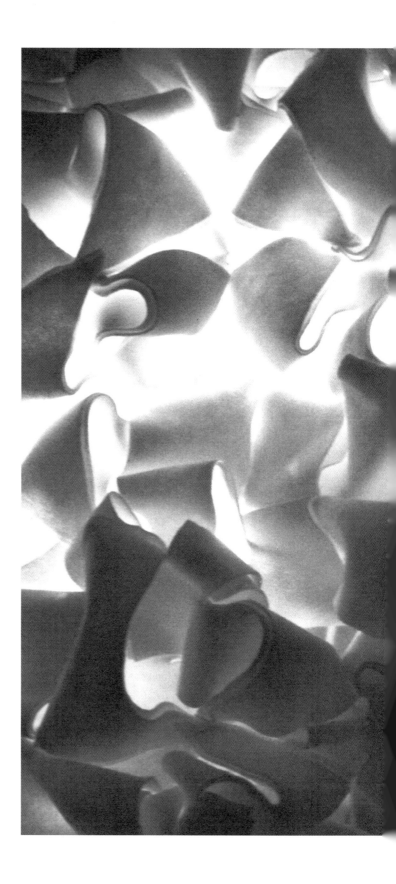

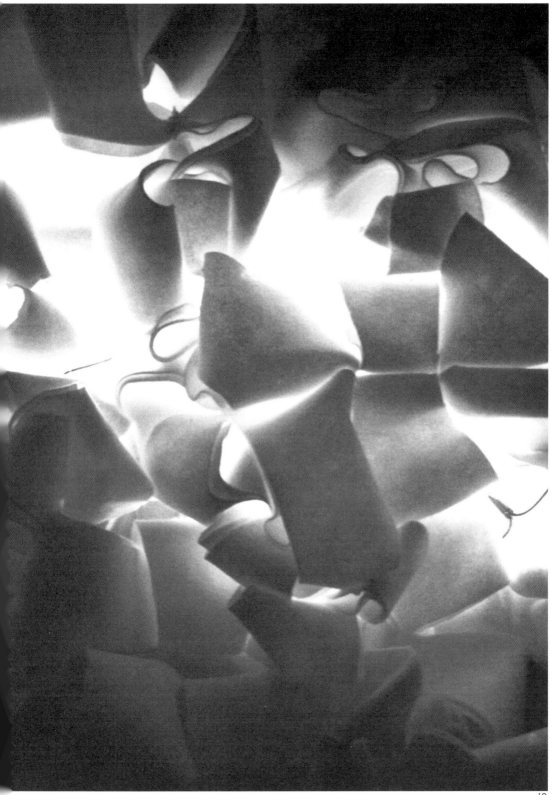

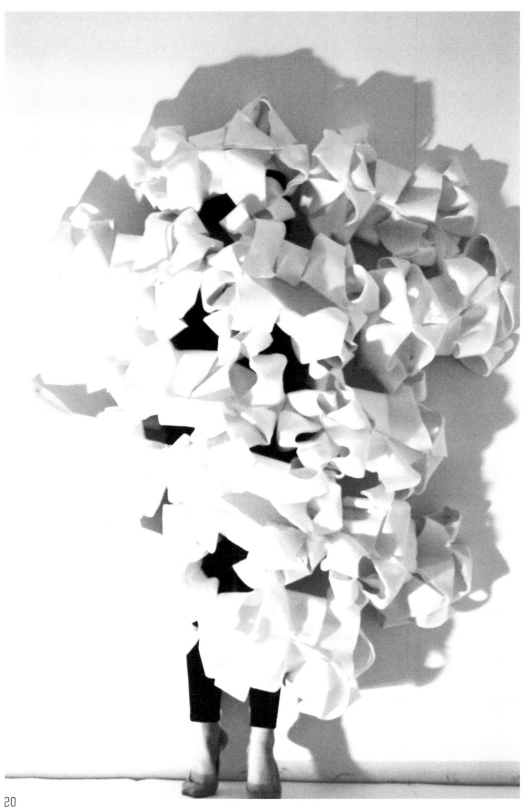

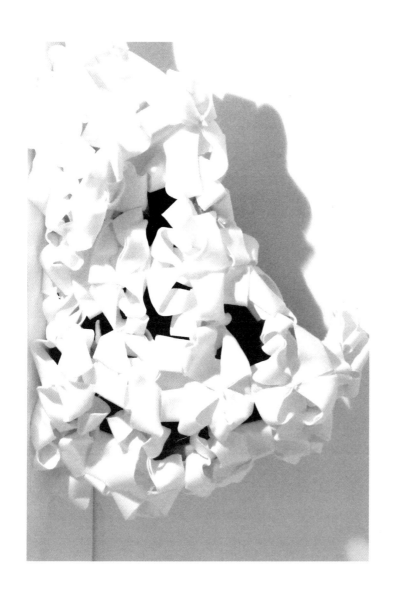

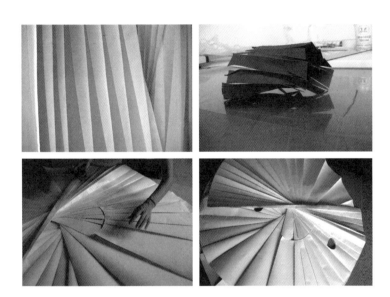

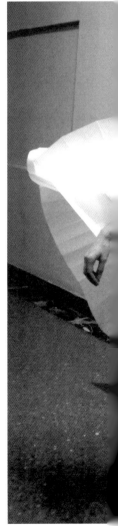

folded stripe

analysis_ pleated cloth by Issey Miyake

textile techniques_ folding
transformation_ folded wearable
materiality_ transparent paper
effects_ compression, expansion, translucency

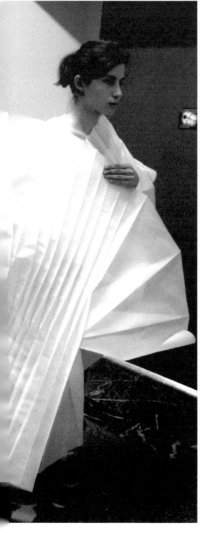 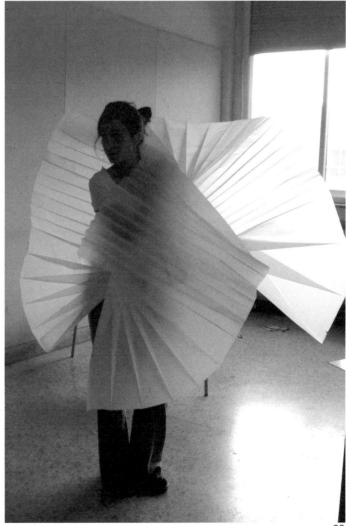

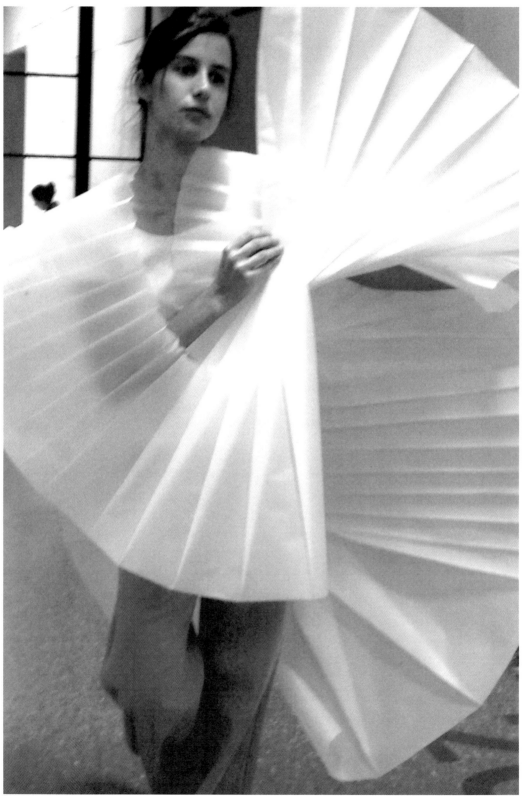

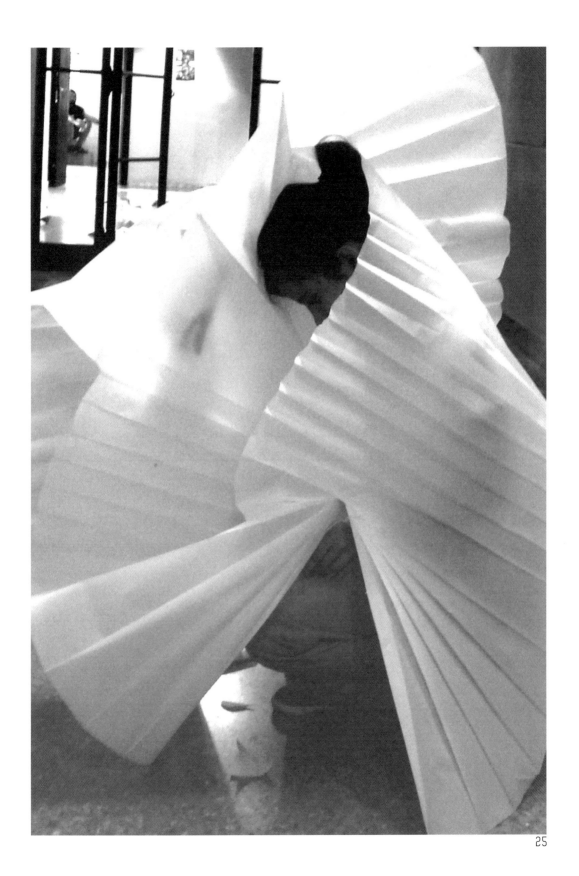

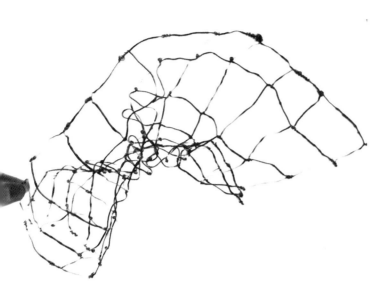

skins & bones

analysis_ drapery of a nomads dress by Christa de Carouge

textile techniques_ pleating, folding, draping, reinforcing
transformation_ controlled simulation of folding,
double-layered panier structure
materiality_ wire mesh coated with an elastic lycra textile
effects_ flexibility, stability, dependency

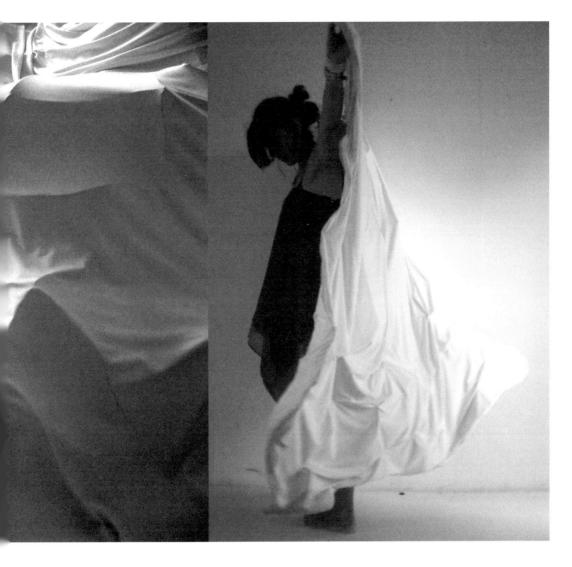

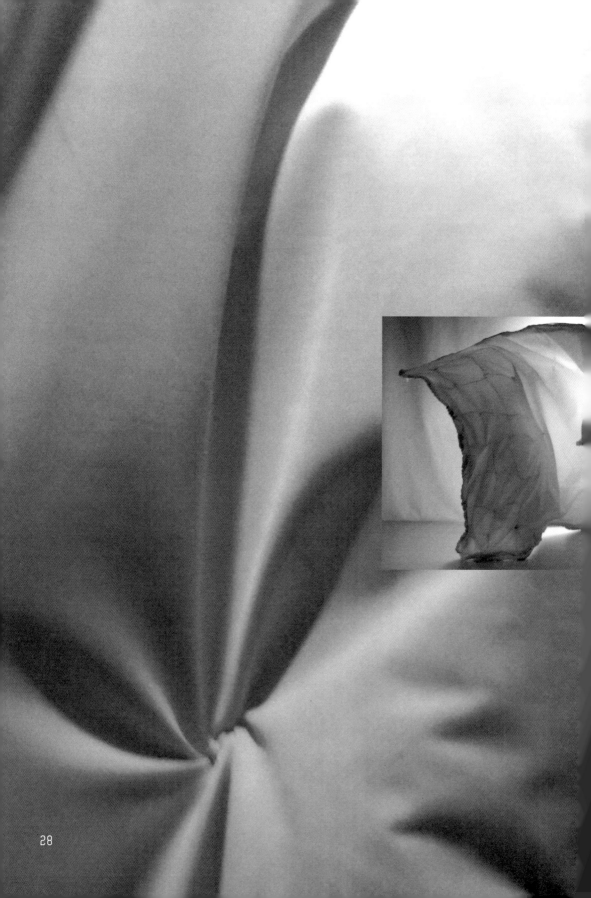

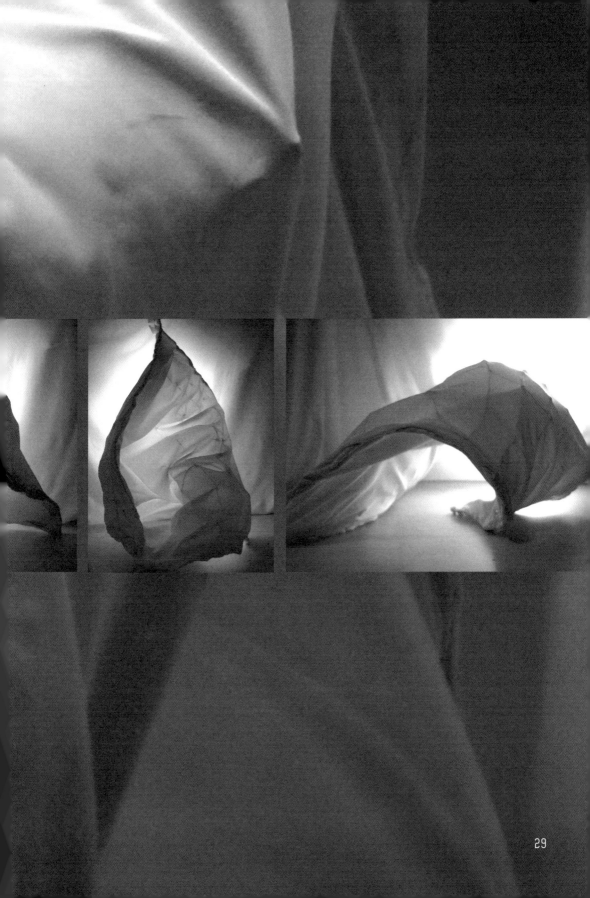

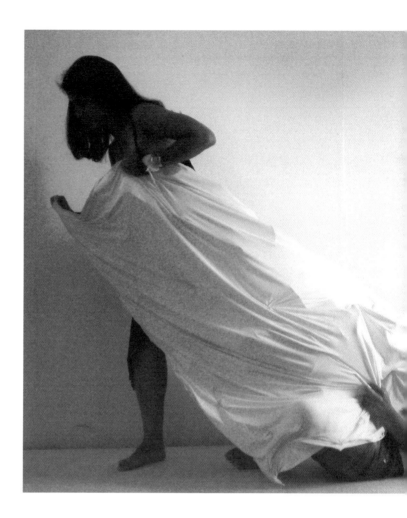

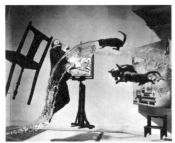

Dali Atomicus, photographed by Phillip-pe Halsman, 1948

Kurt Schwitters 1924-39, Merz building in Hannover

form in architecture

by Aleka Alexopoulou | Sasa Lada

The issue of form, both historically and epistemologically, is part of the discourse on a dichotomy, an oscillation between the positiveness of the external world and the world of ideas, conceptions and interpretations. The same issue appears at the source of the act of creation, operating and enhancing the different approaches to architectural thinking and designing.

Rooted in the debate of idealism-formalism, it expands to other binaries: organic-mechanic, visible-invisible, euclidian -non- euclidian, determinism-indeterminism, real-virtual. Within the realm of contemporary architectural experiment the extensive use of computational design technologies marks the emergence of highly complex dynamic forms indicating a revival of the organic tradition.

Organic has been a part of the concept of early modernism from the very beginning. Architects, artists and scientist have dedicated a lot of experimentation and thought to organic form, appearance and growth. But the modernist project brought forth a new kind of normativity, based on the powerful synergy of artistic, social and economic norms, moving slowly to a shifting of emphasis to industrialization and standardization, equally serving as well the emerging mass-society and its needs.

The mechanic-organic debate of the time included negative connotations of the organic in modernist thinking, as an open-ended, unpredictable process that cannot be governed by the normative logic, a kind of evolutionary metaphor.

In the last two decades the conceptual framework in architecture witnessed a strong resurfacing of the issue of form. Mathematically based procedures and tools, loaned from different disciplines and practices, have given the architects the capacity to manipulate simultaneously most of the known ways of architectural representation, generating highly articulate forms.

In addition, the increasing unity of formal/computational languages has led to a new logic, dissolving the delay between conception and production. Form, however complex, appears simultaneously serial and singular, a fluctuating norm. Whether we perceive the present situation as an architectural evolution or a shift in paradigm, the augmentation and sharpening of our tools of criticism within the architectural discipline – education and practice – are more than ever necessary in order to compensate for the heavy formalism that populates the present, a formalism colored by a rather hasty attitude of a neo-determinism.

The complexity of our visual universe, in this highly innovative period, demands not only theories of perception, more or less present in architectural thought, but rather the enrichment of theories of selection, refined and based on an integrated approach to architecture, a synergy of all the unique, rich and long architectural culture.

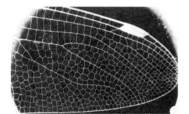

Part of a dragonfly's wing; On Growth and Form, D'Arcy Thompson

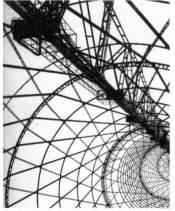

Shabolovska Radio Tower, V.Shukov, 1922, Foto: Richard Pare

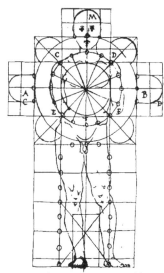

Francesco di Giorgio Martini, Hidden Anatomy, 1482

Form follows bodies?

Architecture has used the metaphor of the body, for its constitution since its very beginning. In that sense the relationship between architecture and the different conceptualizations of the body is fundamental, a mechanism that permits the exchange between the world of ideas to the world of the real. It is a mental construct that establishes analogies and imitations, similarities and differences, correlations and translations from a system of thought to a system of realization. For more than 2000 years classical architecture was based on the Vitrurian notion that the, Doric, Ionian and Corinthian orders, derive from the imitation of the human body.

Centuries later, Georges Bataille, in his well known article *Architecture* (1929) employs the notion of anthropomorphism to refer to the relationship between the body and architecture that occurs under the usual conditions in which the discipline produces its buildings. Anthropomorphic architecture, which accounts for a good part of contemporary production, simply imitates contingent, plural and multiple bodies differentiated by their representative and expressive intentions.

The majority of institutional buildings, as well as private structures and those devoted to leisure take account of bodily forms and behaviors that have generally been accepted, corrected, taught and discerned through the mechanisms used to repress certain behaviors and encourage or implement others.

Oskar Schlemmer, Marionetta, 1926

It is against this architecture that Bataille revolts, denouncing its false objectivity and deceitful indifference. In the present situation any attempt at reconstructing space, determining place, identifying roots or retrieving amorous, industrious, exhausted or gymnastic bodies depends on their fictitious existence and on resistance to their dissolution. Only an art and an architecture that recognize the precariousness of bodies and their objectified fragmentation along with the persistent dynamism and energy that nonetheless continue to circulate in them, are capable of presenting a convincing discourse at the present moment.

Most theories identify the origins of architecture in the solid and protective home. Interestingly enough Gottfried Semper, in his late 19th century writings, argues that architecture originates from woven fabrics, generating and enclosing domesticity, when placed on the ground or hung in the air. He, points out that the beginning of building coincides with the beginning of weaving, and that the woven fabric has precedence over the solid wall.

The transformations of textile geometries, in structure, material and physicality and the resulting capacity to form enclosures of body and movement, were the focal point of the workshop organized in April 2009 in the context of the final year studio on "places in transition" taught by Aleka Alexopoulou and Sasa Lada.

Open ending experimentation, the use of a variety of architectural means and modelling techniques and tools, enthusiasm and fresh ideas were the ingredients of this intense four- day students' workshop, imaginatively prepared, carefully structured, and closely tutored by Gabi Schillig and Asterios Agkathidis.

The richness and diversity of the proposals made possible, if not obligatory, their presentation in the book at hand ,hoping that the documentation could communicate, in a good degree, the flavour of the students visions.

Modulor, Le Corbusier, 1942

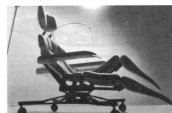

All-Purpose Furniture, Takis Zenetos architecture in Greece,1969

LITERATURE
- Jonathan Hill, "Immaterial Architecture", Routledge, 2006.
- Branko Kolarevic, "Architecture in the Digital Age, Design and Manufacturing", Taylor and Francis, 2005.
- Willy Muller,"F111" in "The Metapolis Dictionary of Advanced Architecture: City, Technology and Society in the Information Age", ACTAR 2003.
- Philip Ursprung, "Herzog and de Meuron. Natural History", Canadian Centre for Architecture, Lars Müller Publishers, 2002/2005.
- Georges Bataille, "Architecture" in Documents 2, May 1929.
- Walter Curt Behrendt, The Victory of the New Building Style, Oxford University Press, 2000

woven mesh

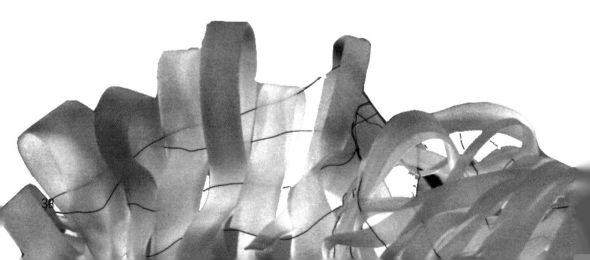

analysis_ the work of Gesine Moritz

textile techniques_ traditional weaving techniques
transformation_ woven wearable structure
materiality_ wire and foam stripes in various thicknesses
effects_ porosity, adaptability, gradually widening surface

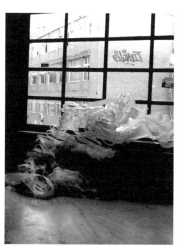 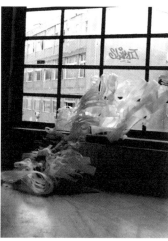 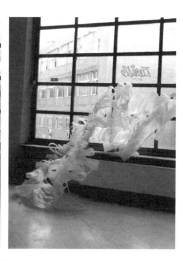

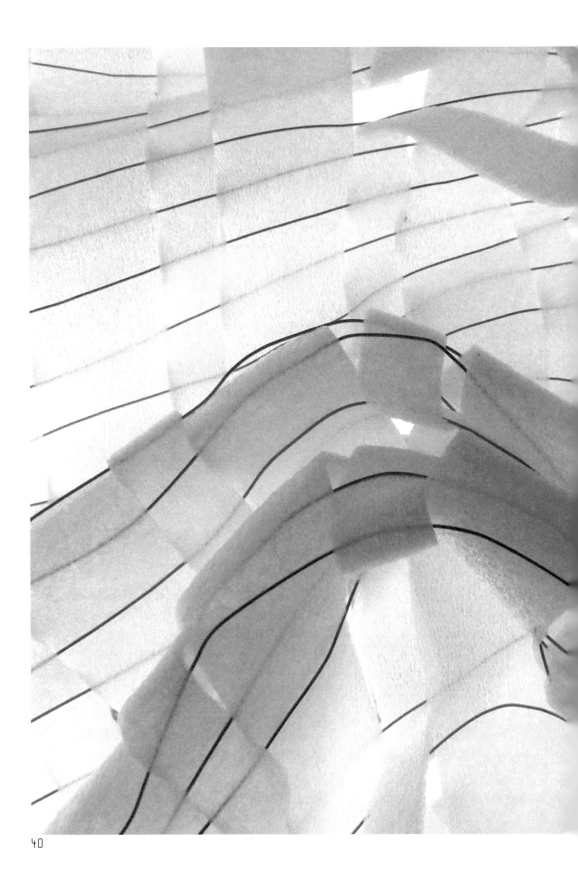

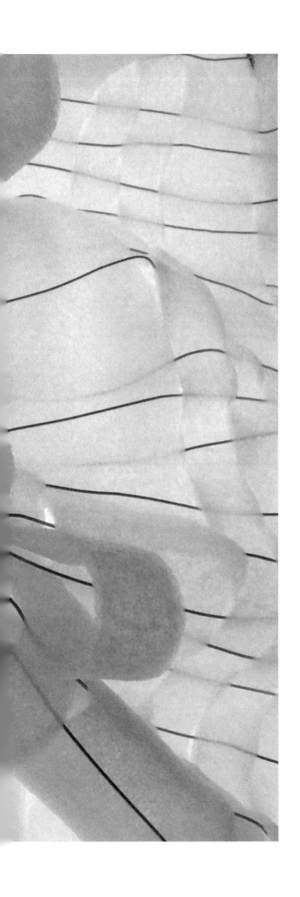

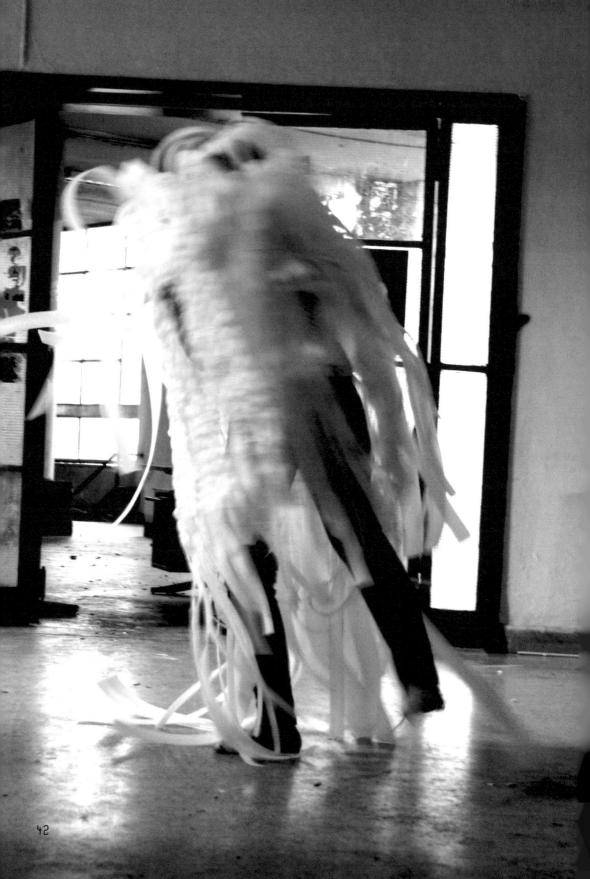

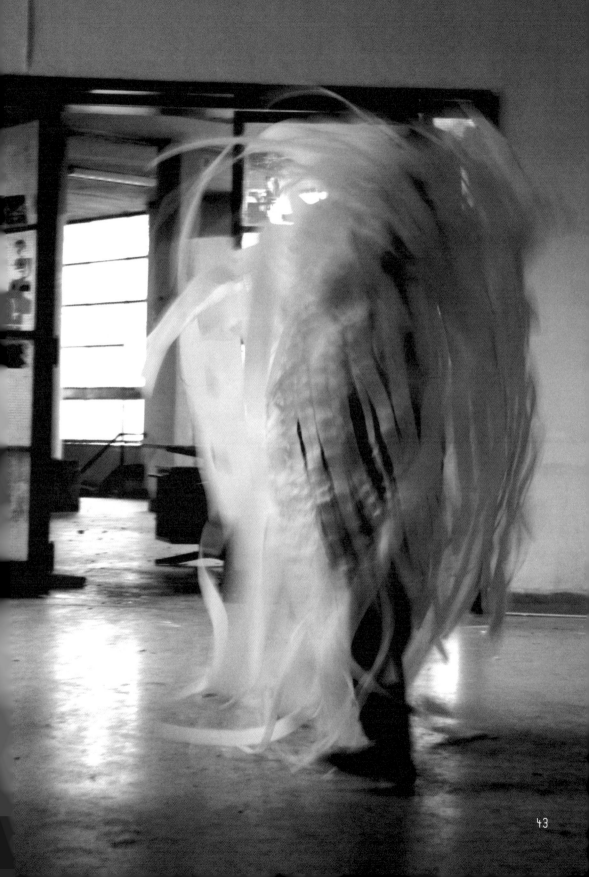

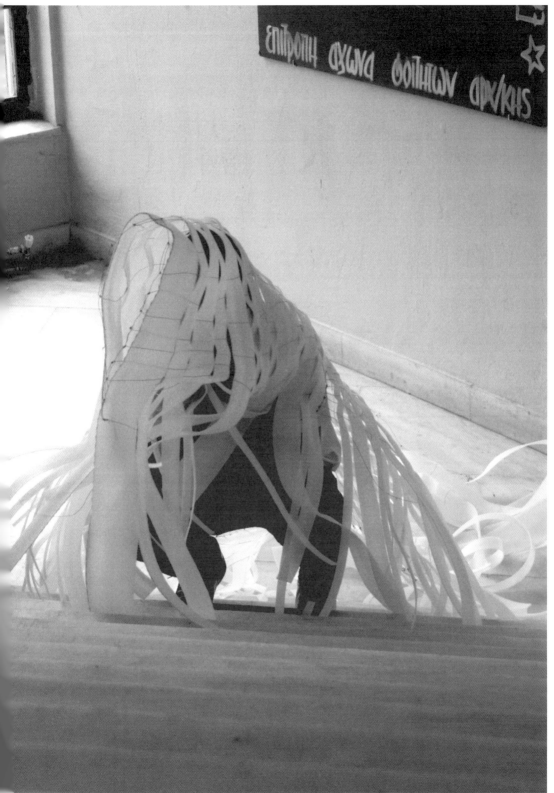

45

skinesis

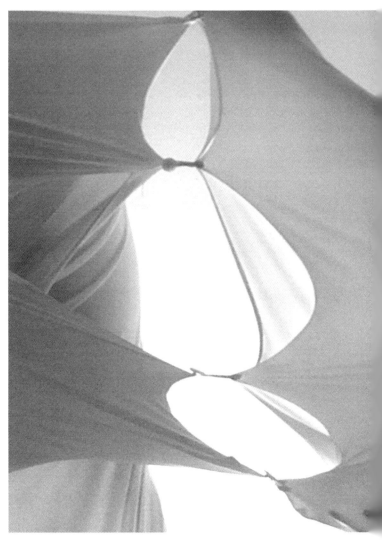

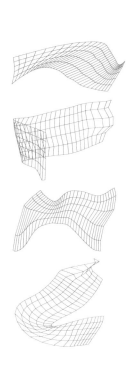

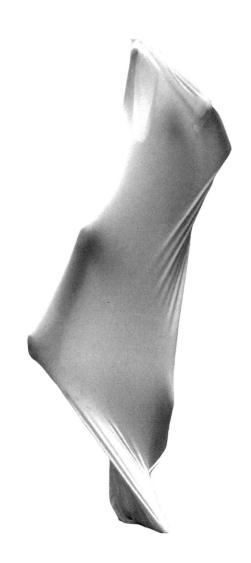

analysis_ the work of Christa de Carouge and
garments of nomadic tribes

textile techniques_ cutting, stitching, interlacing
transformation_ textile envelopes deformed by
a choreographic sequence
materiality_ lycra textile
effects_ tensile strength, opacity, bodily imprint

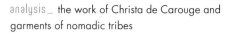

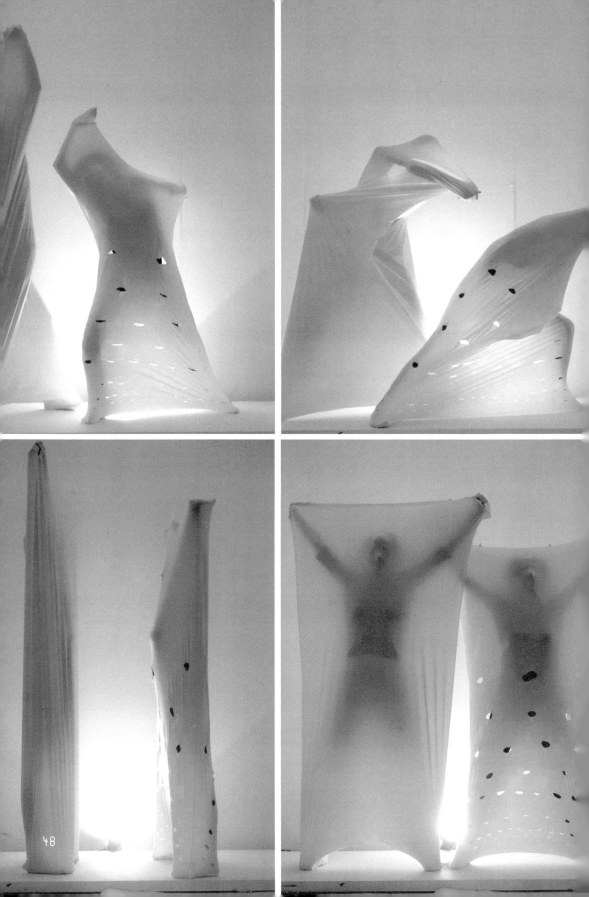

48

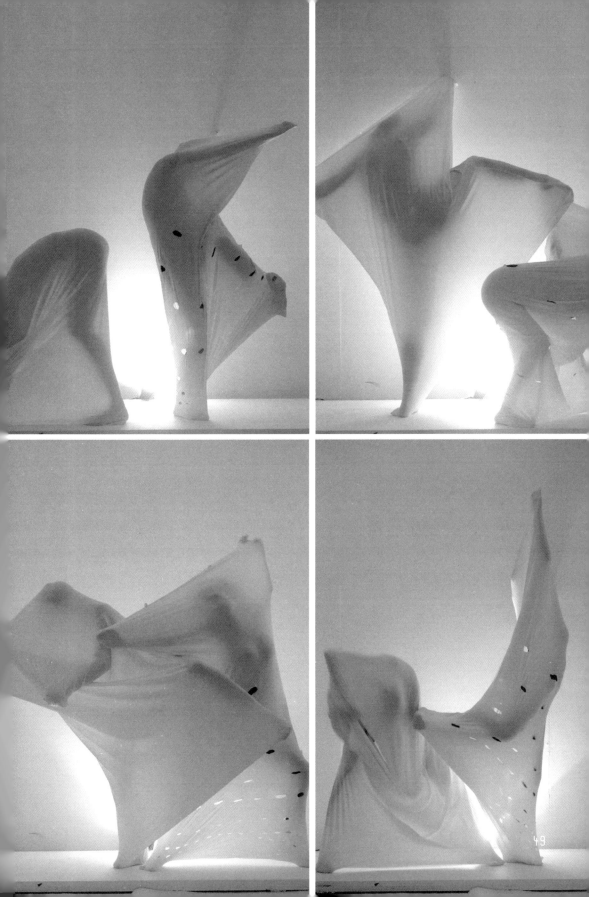

49

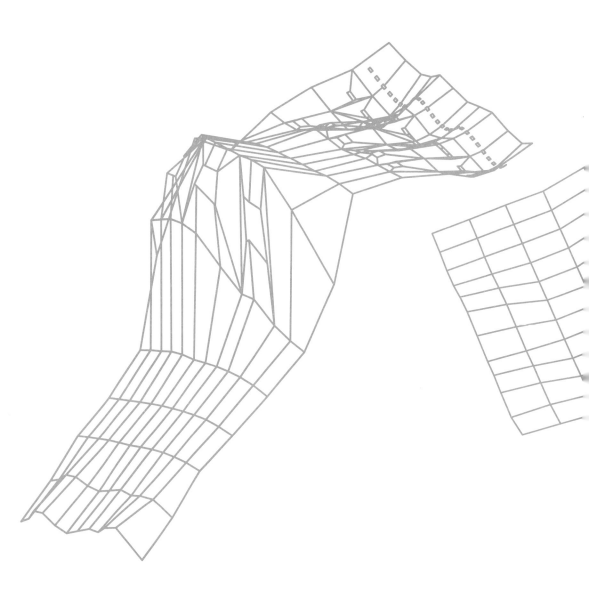

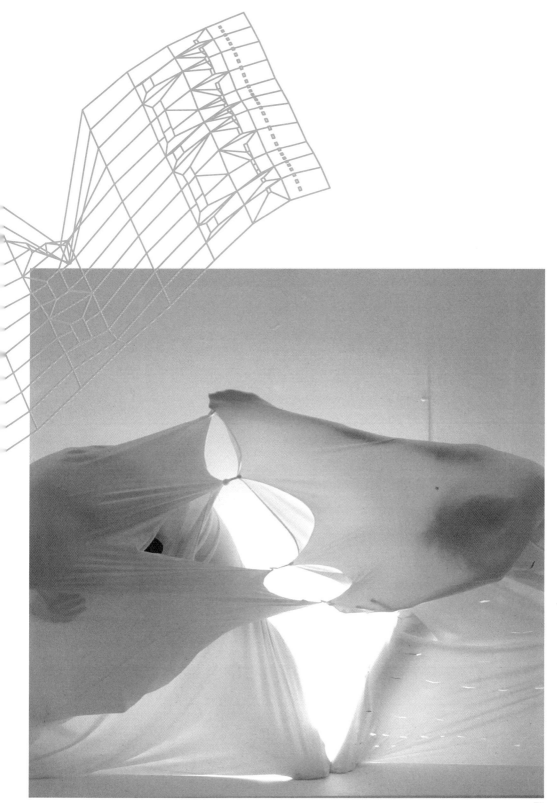

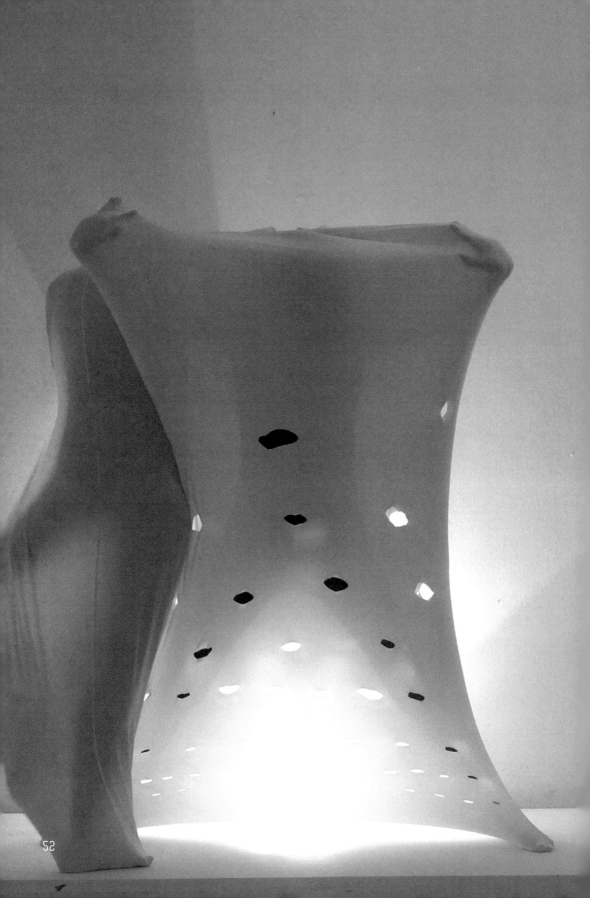

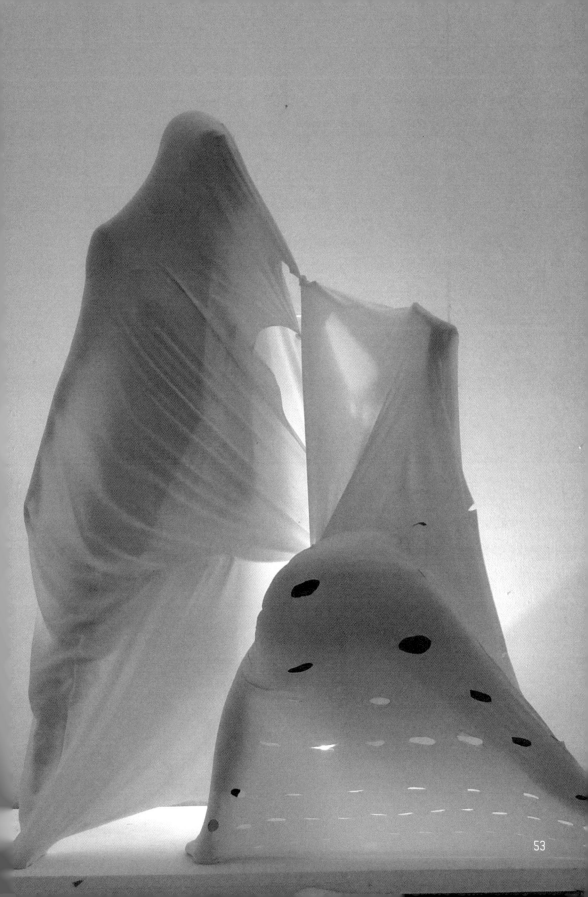

53

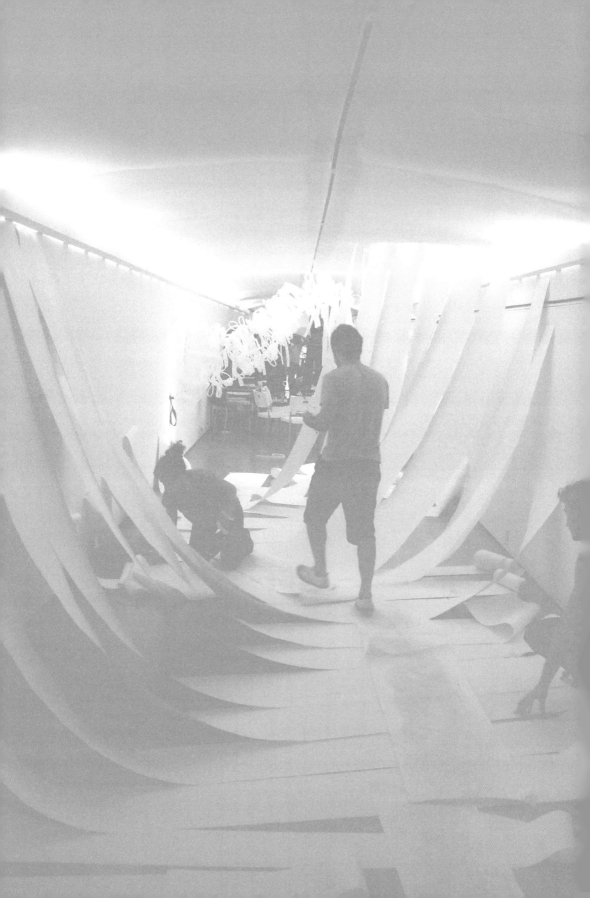

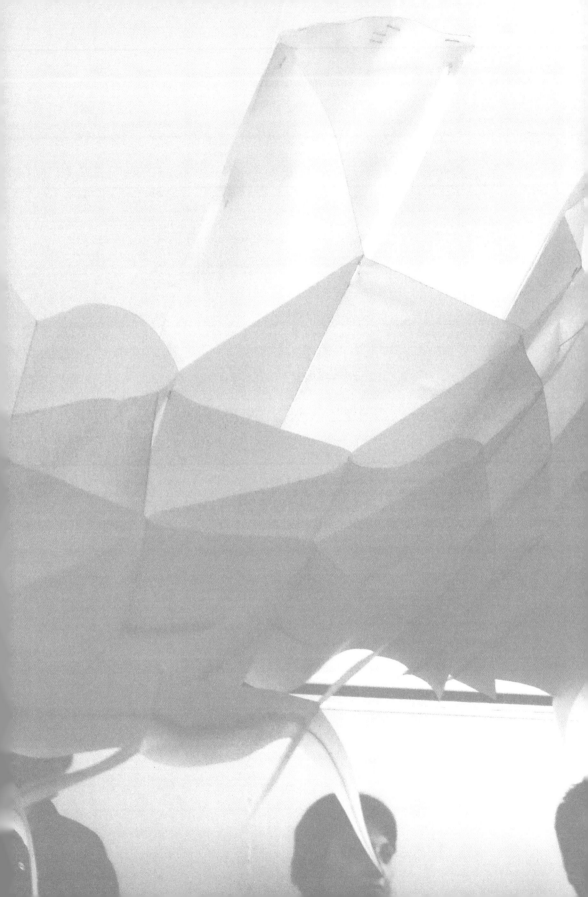

The internet has digitalized and revolutionized the current state of communication and is itself a kind of collective memory. The media theorist William Mitchell describes the otherness of the term "*space*" in cyberspace as follows: "In the world of cyberspace, the ideas of time and space have been turned upon their heads; their categorical demarcations have become confused. Spatial distances are reduced to the time required for data transfer and these will, thanks to advancing technology, fall below the perceptibility threshold at some point. The dissolution of space into dimensionless time turns cyberspace into timeless motion in a place with no location – as it were into a 'no place', a utopos." [1]

Post Modulor by Rouli Lecatsa

media and architecture

by Rouli Lacatsa

'

Manfred Faßler witnesses the effect of media on our method of perceiving: "We, as people living in the present, enter fundamentally changed visual spaces. There, we are registered by visualizations as both reality and reality guarantors, we perceive, decide and differentiate and act in those visual spaces. At the same time, digital images are physically present in our perception. The interactive medial spaces, in which visual images occurs, destroy this visual image with the next click. The single placed images allow for a stream of visualization. Important here is the visibility." [2]

The architectural historian Ulrich Klotz points out that '*the use of software has changed our way of thinking because it changes the way we obtain and interpret information.*' This statement will be decisive for the future development of architecture and urban spaces.

From a dictatorship of codes to cyber architecture

'*Code is law*' Laurence Lessing pronounced in 1999 and by 1995 W. Mitchell was already stating: 'The rules which direct a computer built micro world are precise and strictly determined in the programming code which governs what appears on the screen.' [3]

By employing computer technology, design methods and theories have been developed. A new formal architectural language has emerged which proposes radical typology for building design. In their work, the architecture avant-garde such as Peter Eisenmann, Daniel Libeskind, Winy Maas, Ben van Berkel, Lars Spybroek (Nox), Ashton Ragatt, McDowell (ARM), Hani Rashid (Asymptote), amongst others, are searching for a new dimension in architecture as a reaction to the fact that the classic triptych '*space, time, architecture*' demands a revised definition today. The opinion that the whole is in fact a developing whole and not a finished work as the Modern has alleged, has consequences for the understanding of reality and the reflection on urban spaces.

The vast majority of the world's population now lives predominantly in cities. The consequence of this concentration is the densification and assimilation of different cultures, of technological progress and tradition. The term 'urban landscape' refers to a living space which combines and links its functions like an enormous network. New types of buildings and usages are required which takes more efficiently into consideration the development of the markets, the management of resources and the change brought about in working methods due to computer technology.

The structural changes also affect the spiritual behaviour of society and its cultural identity. The future is assigned to an architecture where the design process moves away from traditional criteria. Function and form are separately dealt with. The aim is to include a system of external factors into architecture. These form the parameters for the design through their mathematical superimposition, stratification ect., with the help of highly complex specific software programs. These factors pertain to the influence of noise, electrosmog, regulations and laws, natural influencing factors such as topology right through to social needs. These parameters are closely connected to one another through complicated diagrams. Through this more possibilities and project scope become visible. Several different and future-oriented approaches have been tested and developed. They all have one common feature: the final shape is not predictable. It is the result of more abstract parameters which have more in common with algorithms and mathematics than with the geometric structure. It is rather a question of a new definition of 'structure', of unravelling the form into flowing shapes. The 'external' should be fixed but the influences should be incorporated on its surface. An example of such an architectural concept is the work of Greg Lynn with his exemplary 'hydrogen house' as the typical 'animated form'.

Morphing by Rouli Lecatsa

Greg Lynn on this topic: "From static to animated or virtual living requires the transition of the fixed topological order into a developing process, from autonomy to contextual sensibility and from holistic organism, relating to the whole human, to fusion and unification." [4]

The '*disembodied awareness*' in the world of cyberspace initiates the dissolution of the structure in architecture.

It is the search for a processual linking of diverse factors. Fractal geometry is often deployed here. According to the architectural historian Charles Jencks, it is a matter of "order, which is like a mass of rules always self-similar and slowly developing, an order which is more sensible and surprising than the mechanical repeating of similar elements." [5]

At the beginning of the twenty-first century, science admits that there are no definitive solutions. The development of society is subject to the increase in ambiguity, uncertainty and insecurity. The positive acknowledgement of boundary polarization is expressed in architectural concepts where the building is seen as a continuous topological area which can be influenced by the author but which cannot be exactly determined. In the sense of an endless continuity, each single change ultimately influences the whole. Content and meanings derived from contradictions and opposites are characterized by their variety. They are not static. In the field of architecture, the carrying out of research in the new sciences has not yet been fully developed. Through the application of the increasing opportunities provided for by the computer, methods are being developed which enable visualizing the real world in another way and the revealing of aspects which would otherwise remain '*invisible*'.

In conclusion, we are able to observe that the virtual media models lay claim to their right to exist in the real world. Accordingly, theory formation in architecture takes on greater significance today.

NOTES
1) Stefan Müncker, Alexander Roesler, „Die neue Ökonomie der Präsenz",
Frankfurt/Main, 1999
2) Manfred Faßler, „Bildlichkeit", Wien 2002
3) William Mitchell, Derrick Kirkekove, „Die Architektur der Intelligenz",
Basel, 2002
4) Greg Lynn, in „Cybertecture"
5) Charles Jencks, in „Cybertecture"

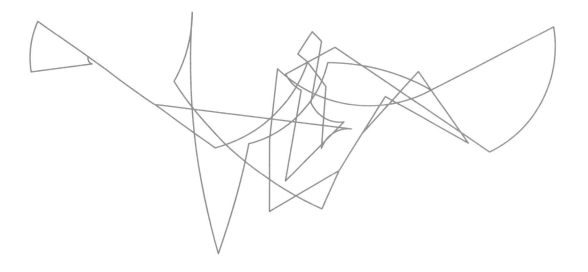

reactor

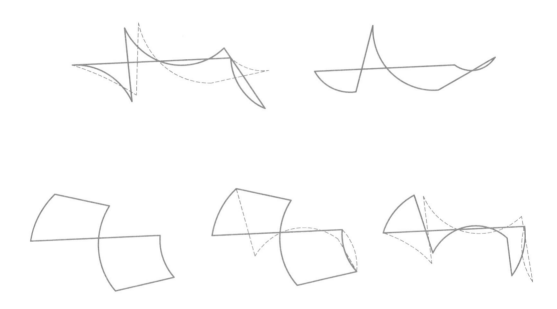

analysis_ hive textiles and their unrolls

textile techniques_ unrolling, knotting
transformation_ movable wire frame with flexible joints
materiality_ metal wire
effects_ rotational movement, dissolution of lines in space, connectivity

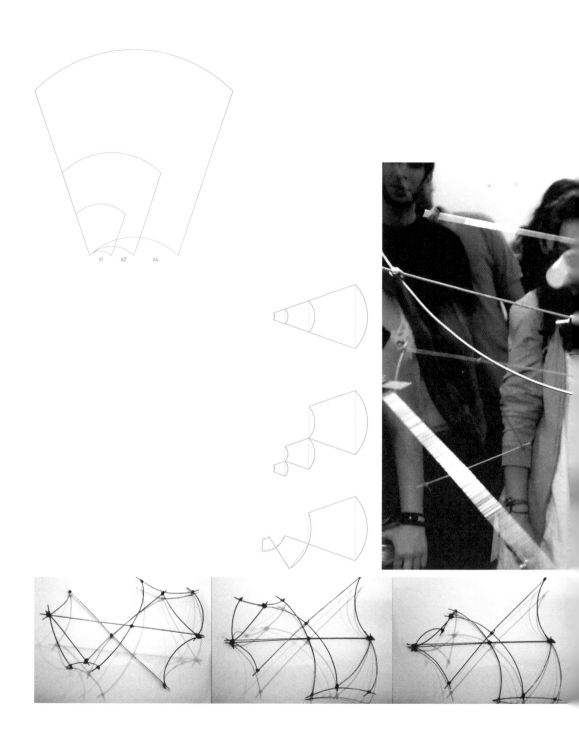

x1 x2 x4

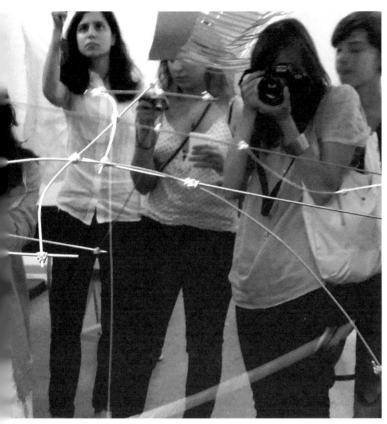

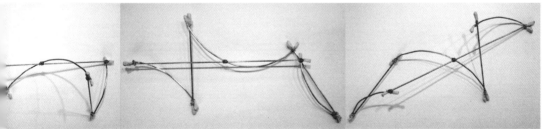

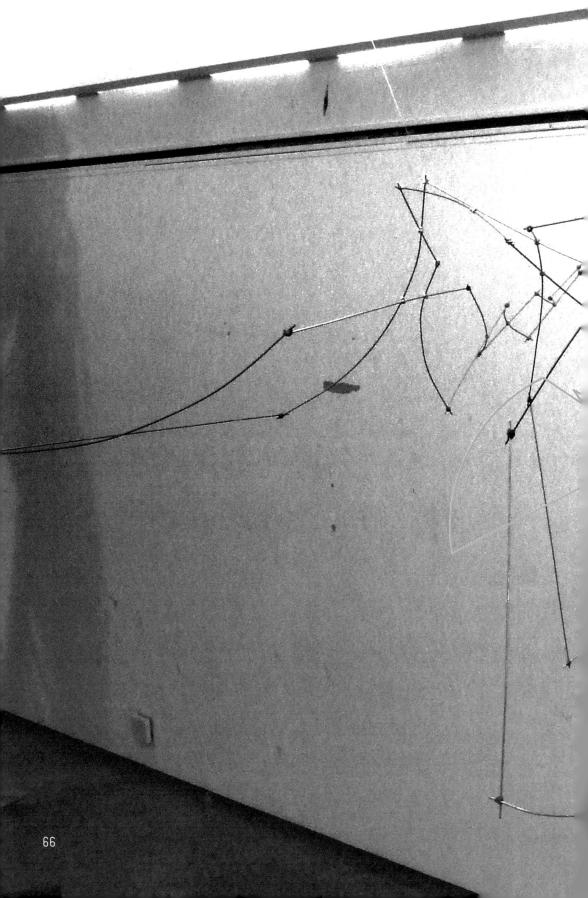

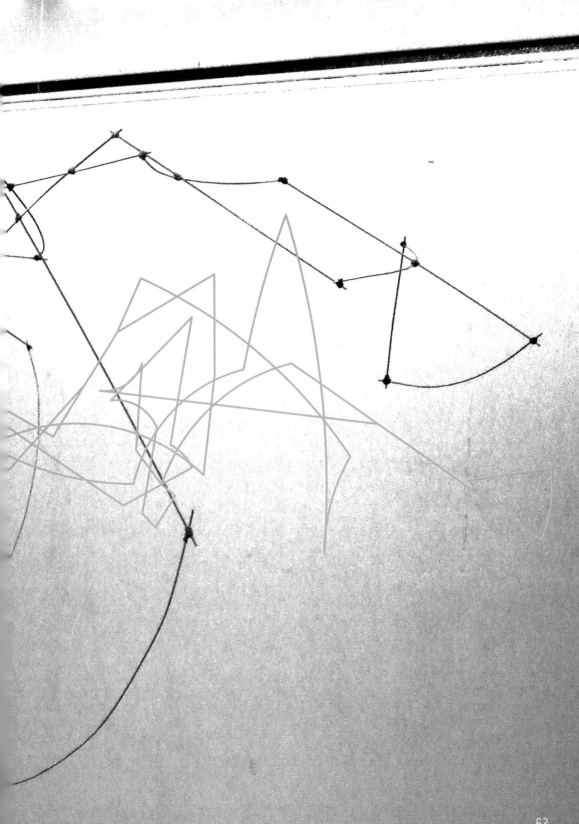

animated linearity

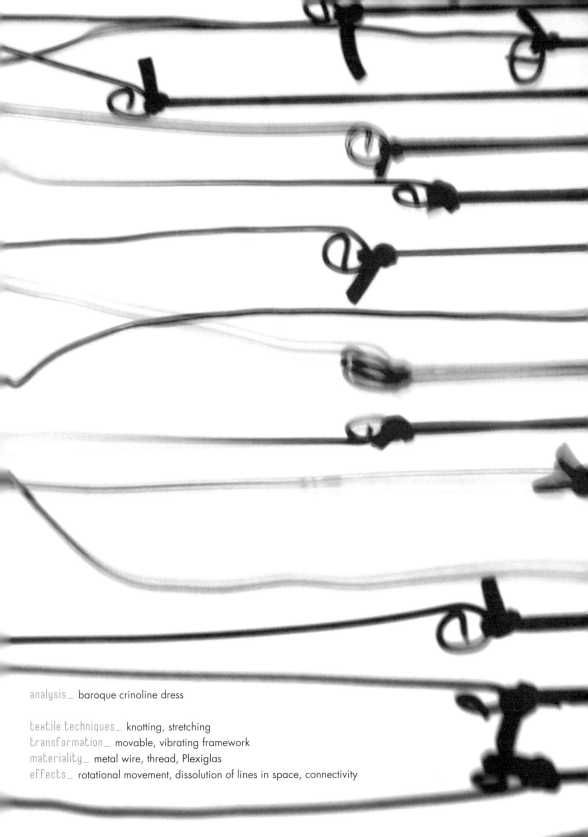

analysis_ baroque crinoline dress

textile techniques_ knotting, stretching
transformation_ movable, vibrating framework
materiality_ metal wire, thread, Plexiglas
effects_ rotational movement, dissolution of lines in space, connectivity

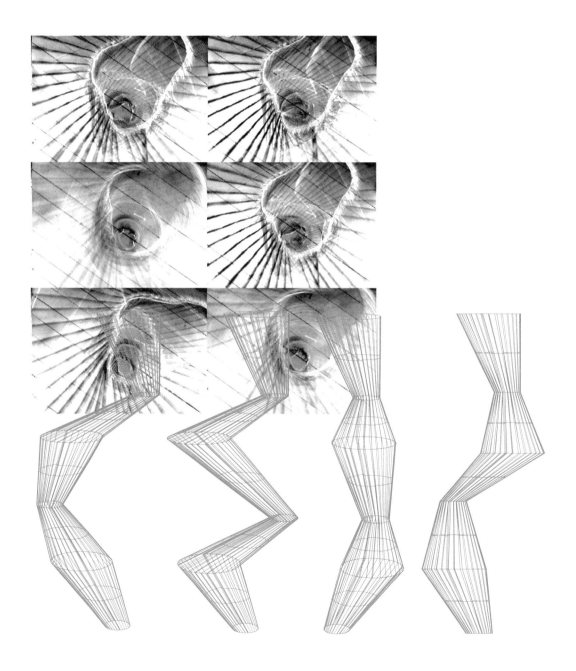

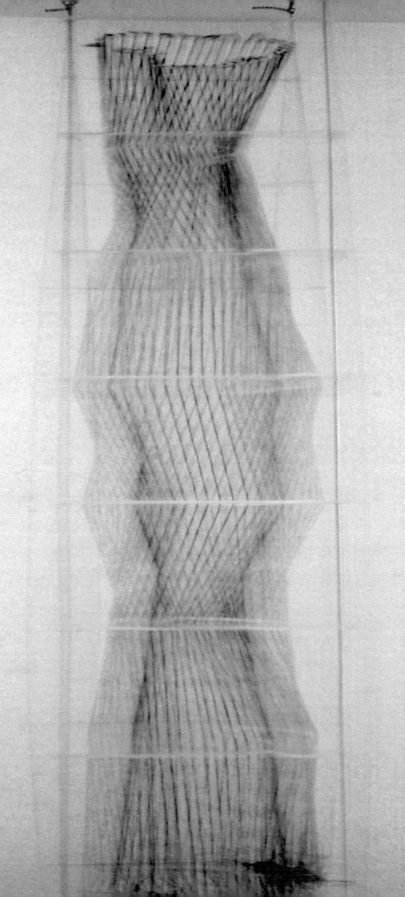

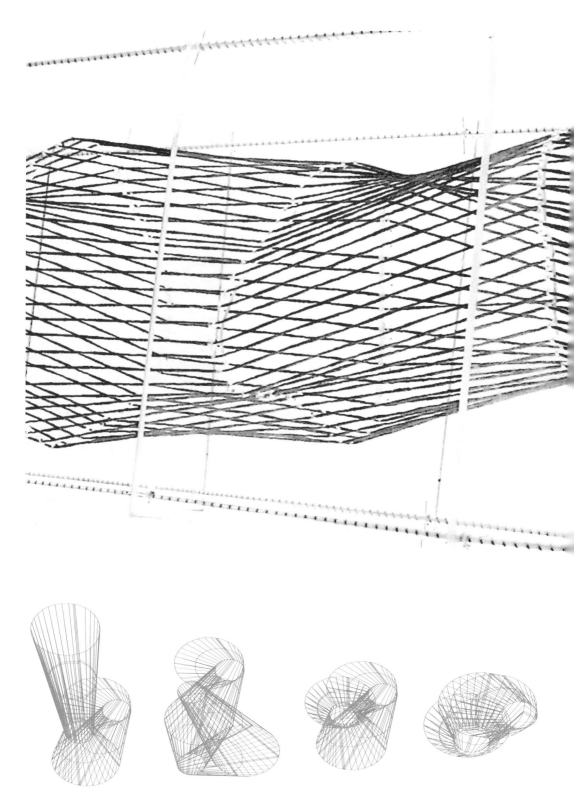

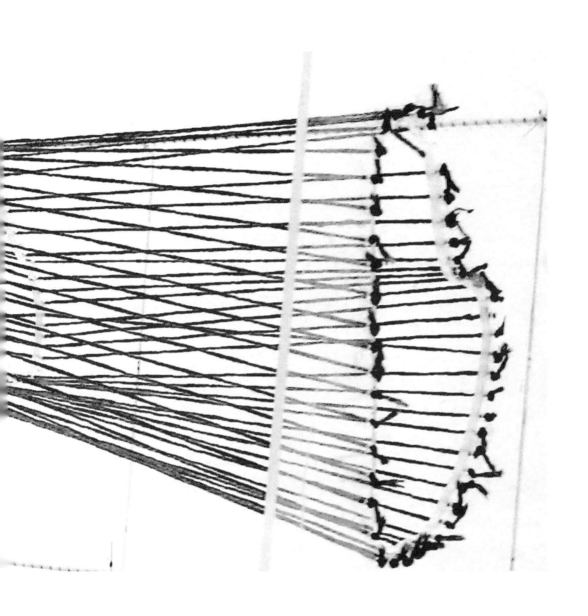

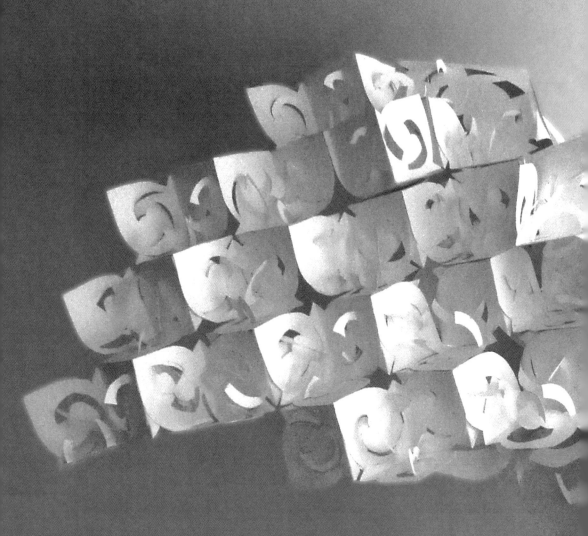

laced cluster

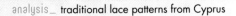

analysis_ traditional lace patterns from Cyprus

textile techniques_ cutting, folding, layering
transformation_ modular cluster
materiality_ paper
effects_ transformability, flexibility, deep surface

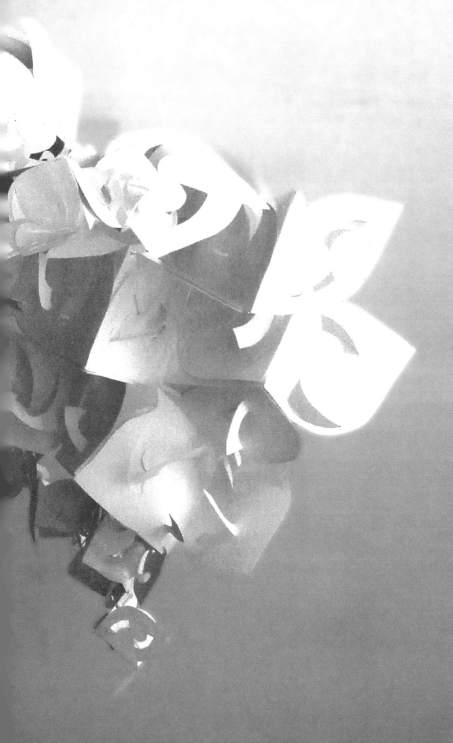

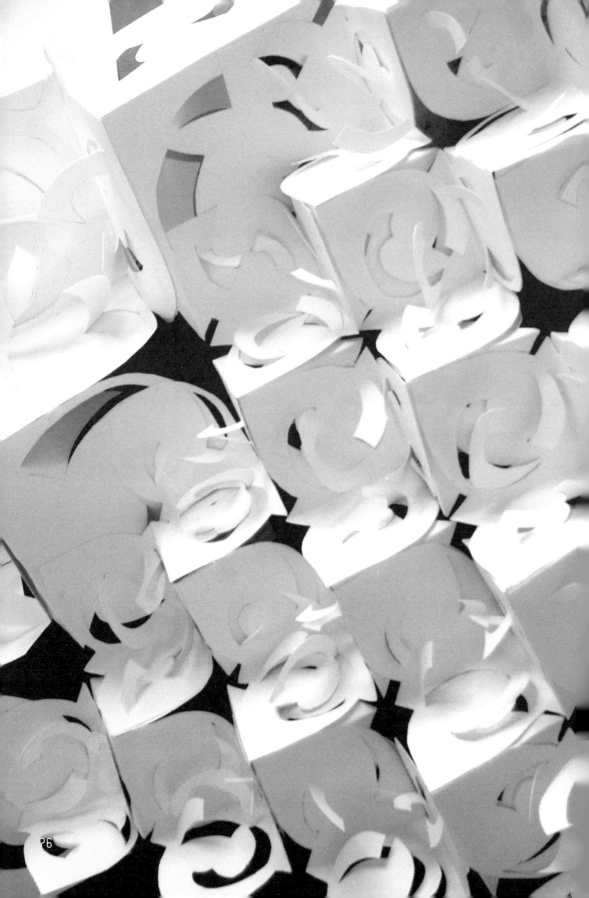

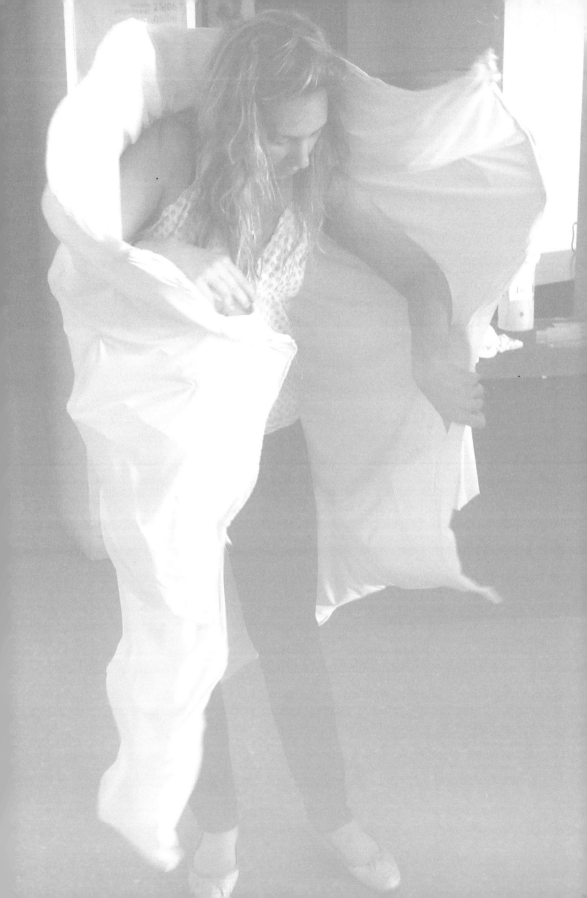

3 research studies related to lightweight structures in the city and 13 relevant architectural projects.

When I was asked to contribute an article to this present wonderful architectural publication, I decided to present three interesting research studies, which took place at the Institute of Lightweight Structures (IL), University of Stuttgart, during 1975, where I spent four years (1973-77), as a young architect and close collaborator of Professor Frei Otto, at IL and at his private office Atelier Warmbronn (AW). At the same time I would like to present to you thirteen of my favourite architectural projects of lightweight structures either from this period of time or from other later periods, that have also been creative and exciting for me.

3 research studies and
13 architectural projects
by George Papakostas

The first research study *Lightweight Structures in the City*[1] aims to specify possible implementations of lightweight structures made of prestressed membrane (textile or net) in the city.

Without reference to the inherent multi-functionality of lightweight structures and the infeasibility of their classification according to function, this research considers the most relevant applied paradigms recorded at the time of this research. It also examines a vast array of new architectural synthesis proposals regarding traffic zones (roads, sidewalks, parking places, gas stations, railway stations, harbours, and airports), consumer zones (commercial roads, squares, parks, vacant spaces, markets) and leisure time zones (exhibition halls, theatres, cinemas, concert halls, discothèques, restaurants, cafeterias, sports' installations, and sites of archaeological interest) which are integrated in the city.

The necessity to integrate lightweight structures in architectural and urban design is also discussed, and it is sustained by arguments either based on systematic study of the characteristics of lightweight structures (design methodology, technology, morphology, flexibility, multi-functionality) or in conjunction with features of urban environment such as those of being 'familiar' or 'alien'.

The second research study *Prefabricated Systems*[2] aims to investigate various possible, useful and flexible prefabricated systems made of prestressed membrane (textile or net). Emphasis is given mostly to their geometric characteristics, the construction technology of their systems, the differentiation of their scale and their architectonic quality. Most of the prefabricated systems have been tested by the authors through sketches, drawings and small models. Finally more than fifty possible implementations of these prefabricated systems made of prestressed membrane (textile or net), are presented.

The third research study *catalogue of Pneumatic Structures* [3] aims to stimulate artists, architects, engineers and manufacturers in the field of pneumatic constructions, to indicate new possibilities for research and to facilitate tracing of literature.

The author attempted to find the most important features of all related projects and construction systems published, planned or constructed until 1972, on the basis of the existing illustrations and to concisely express them by sketches. A catalogue of approximately.1800 sketches was the result. A loose arrangement of topics is represented such as laws of formation, geometry, internal and external agent types, internal pressure types, design details and combination forms.

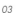

01

02

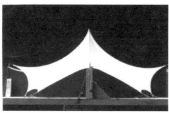

03

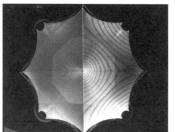

The collection presents different forms, functions and design principles of pneumatic structures and shows how they can be mutually exclusive. An almost infinite number of forms can be applied, yet an equal number exists that serve no specific function or principle and many of these forms cannot claim architectonic or artistic merit. New possibilities were opened up some of which have been realized by now and others are still under consideration architectural researchers and experts.

I will now present the catalogue of thirteen of my favourite architectural projects of lightweight structures:

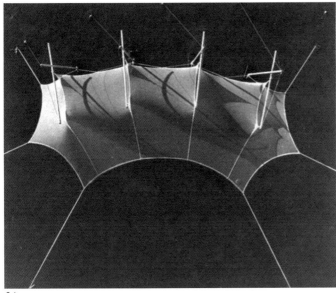
04

01. 1973, *Garden Exhibition With a Bird Cage*, Ludwigsburg, Germany, for: Municipality of Ludwigsburg. Architects: F. Otto, E. Bubner, M. Banz, J. Goedert, A. Lieven, G. Papakostas.

02.1973, *a Tent For Multiple Uses, Ahmenabad*, India, for: Sarabhai International. Architects: F. Otto, E. Bubner, M. Banz, K. Block, F. Denner, J. Goedert, A. Lieven, G. Papakostas, G. Wright. Production: Sarabhai International and Balonfabrik Gmbh + Co K.G.

03. 1974, *Exhibition of a Historical Carousel*, Smithsonian Institution, Washington D.C., U.S.A. for: Smithsonian Institution. Architects: F. Otto, E. Bubner, M. Banz, J. Goedert, G. Papakostas. Civil Engineers: Ove Arup + Partners.

04. 1974, *A Tent Over the Stage, of an Open Air Theatre*, Scarborough, England, for: Trident Television. Architects: F. Otto, E. Bubner, M. Banz, J. Goedert, G. Papakostas. Civil Engineers: Ove Arup + Partners.

05. 1974, *A Multiple Tent For a Sport Area*, Oman, United Emirates, for: Gehrmann Consult and Test, Beirut, Lebanon. Architects: F. Otto, E. Bubner, M. Banz, J. Goedert, G. Papakostas. Civil Engineers: Ove Arup + Partners.

06. 1974, *Cooling Tower for a Power Station*, Frankfurt am Main, Germany, for: Hoechst AG.Architects: F. Otto, E. Bubner, M. Banz, J. Goedert, G. Papakostas. Civil Engineers: Ove Arup + Partners.

05

06
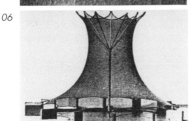

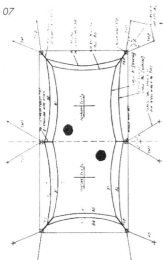

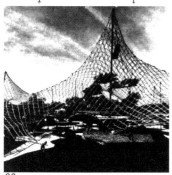

08

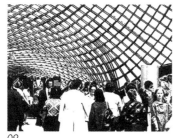

09

07. 1974, A *Tent For a Tennis Court, Hammamet*, Tunisia, for: Farbwerke Hoechst AG. Architects: F. Otto, E. Bubner, M. Banz, J. Goedert, G. Papakostas. Civil Engineers: Ove Arup + Partners.

08. 1974, *University Centre for Research and Technology*, Monarto, South Australia, for: Ministry of Education Australia. Architects: F. Otto, E. Bubner, M. Banz, J. Goedert, G. Papakostas, G. Wright. (in collaboration with Studio Kazanski and R. Gutbrod Architects), Urban Study: Shankland Cox Partnership.

09. 1975, *Garden Exhibition With a Multiple Use Dome*, (Gridshell) Mannheim, Germany, for: Municipality of Mannheim. Architects: C. Mutschler + Partners, F. Otto, E. Bubner, M. Banz, J. Goedert, G. Papakostas. Civil Engineers: Ove Arup + Partners.

10. 1984, *10 Stages for the Spring Cultural Events*, Thessaloniki, Greece, for: Municipality of Thessaloniki. Architects: L. Papadopoulos, G. Papakostas, D. Tzika.

11. 1984, *Olympic Swimming Hall*, Chios, Greece, for: Greek Ministry Of Culture, Sports Authority, Municipality of Chios. Architects: Elias Gounaropoulos, George Papakostas. Civil Engineer: K. Milonas.

12. 1991, *Portable Cultural Exhibition for Copenhagen* (Cultural Capital of Europe, 1996) and a network of other European ports, for: Port Authority Copenhagen, Danmark and the Organisation Copenhagen Cultural Capital of Europe, 1996. Architects: G. Papakostas, O. Vangaard.

13. 1991, *Exhibition Area of the Octagon Monument at Philippi Archaeological Site*, Kavala, Greece for: Greek Byzantine Archaeological Authority, Kavala, Greece. Architect: G. Papakostas. Collaborators: A. Bakirtzis, Ch. Bakirtzis.

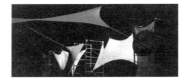

10

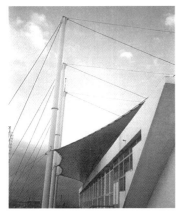

11

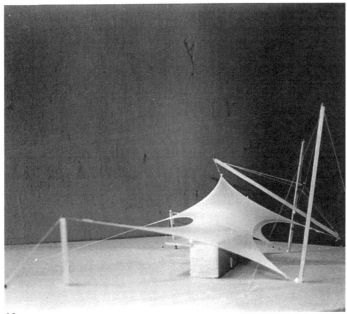

I know that it often takes a long time for information to reach those who need it. Even at our present post-modern era of i-phone and Facebook. With my contribution to the present publication I hope to stimulate cooperations and interdisciplinary works and thus assist in improving the modern lightweight structures made of prestressed membrane as well as their architectonic and artistic qualities.

12

NOTES
1) M. Banz, J. Goedert, G. Papakostas, Leightweight Stuctures in the City, IL, Stuttgart 1975, pp. 105,2) Manfred Faßler, "Bildlichkeit", Viena 2002,
2) M. Banz, J. Goedert, G. Papakostas: Prefabricated Systems IL, Stuttgart 1975,
3) G. Papakostas Catalogue of Pneumatic Structures Article, pp. 108-153, Publication, E. Bubner, B. Burkhardt, J. F. Denner, R. Kurzweg, A. V. Lieven, F. Otto, G. Papakostas, E. Shaur, B. V. Shoor, "Convertible Pneus", IL 12, Stuttgart 1975

13

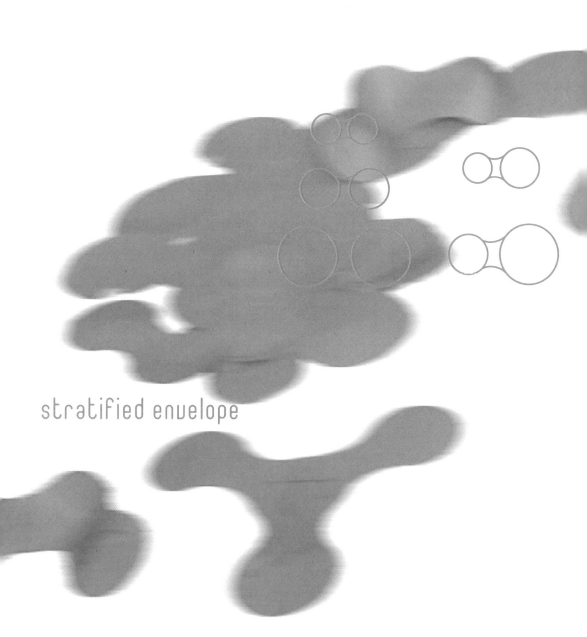

stratified envelope

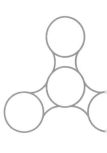

analysis_ dress by Maison Martin Margiela, fabricated out of conical badminton balls
textile techniques_ folding, layering, multi directional combination
transformation_ variations on conical geometries in size - morphing single cones to
multiple conical variations
materiality_ cardboard, different colors
effects_ spatial density, layered tectonics, multiple stratification

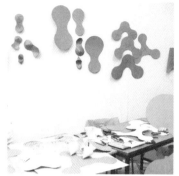

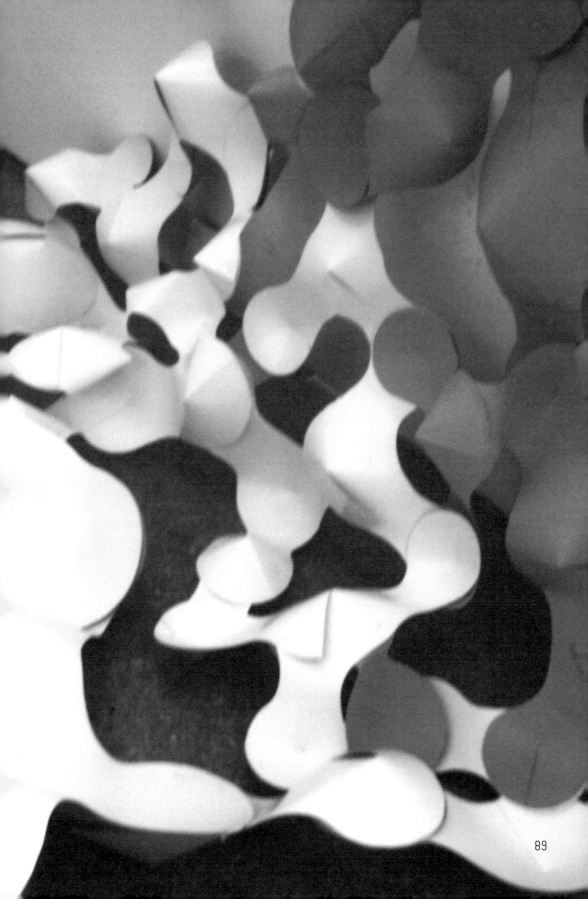

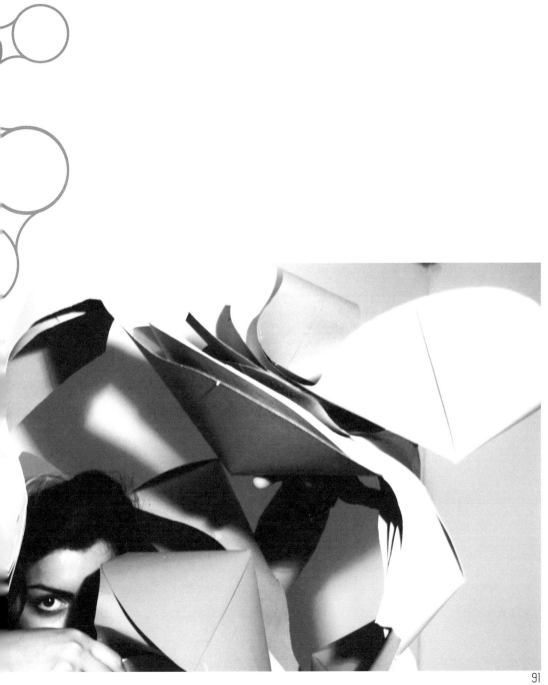

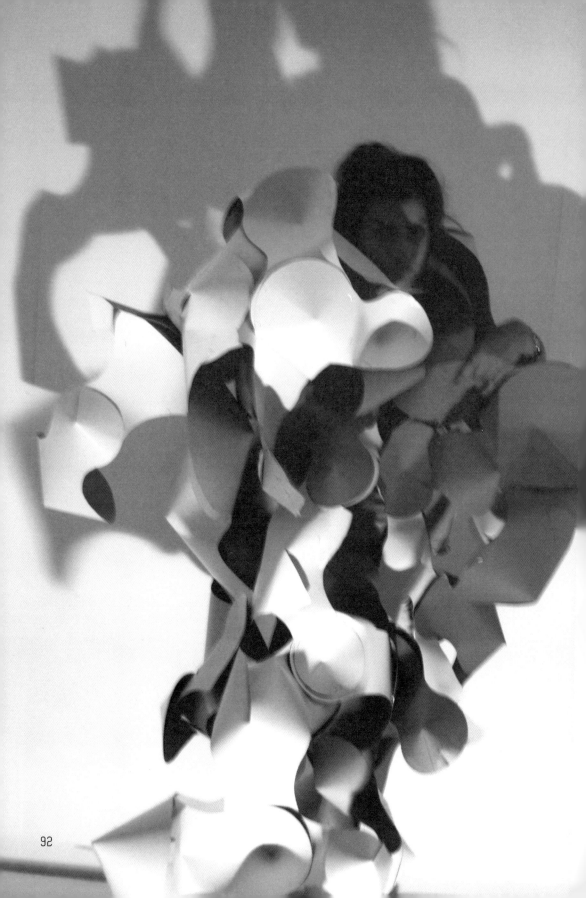

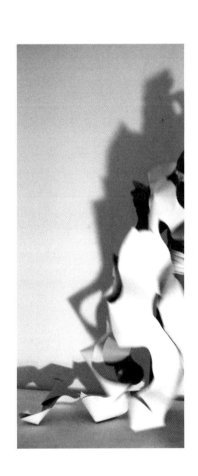

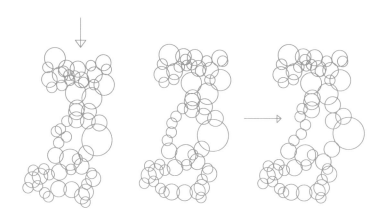

rotational centers

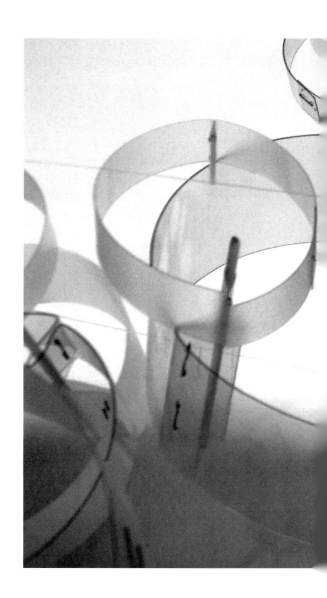

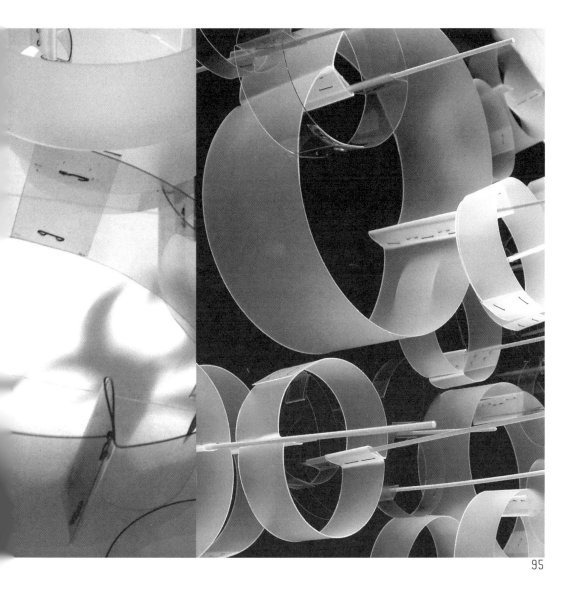

analysis_ transformable skirt from the
Afterwards collection by Hussein Chalayan

textile techniques_ layering, interconnecting
transformation_ ring conglomeration
with flexible joints
materiality_ PVC sheets
effects_ ephemerality, varying shadows,
dissolution of objects

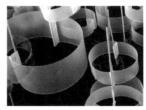

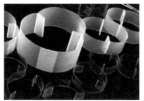

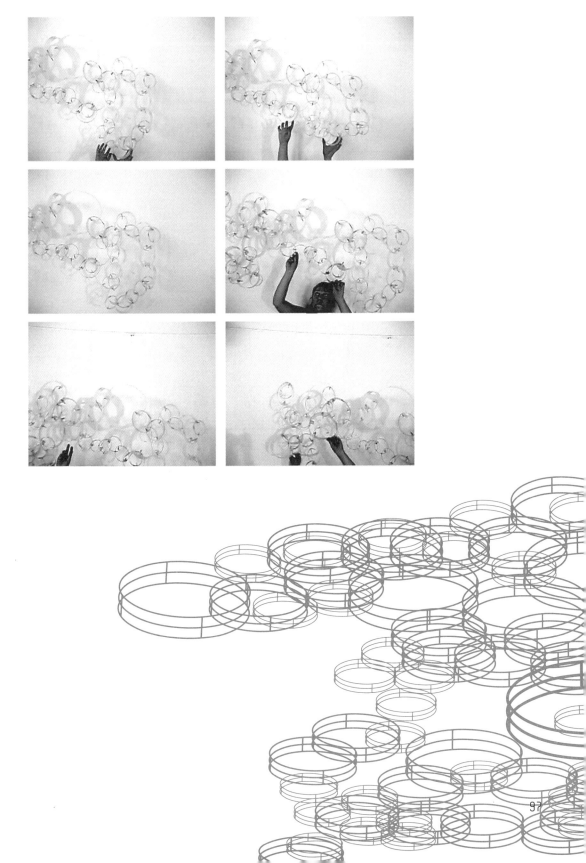

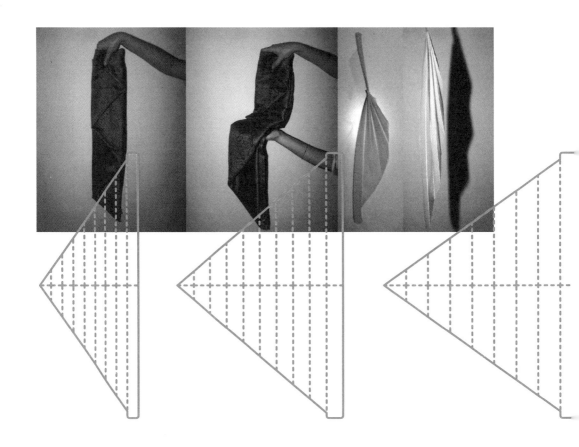

graded formations

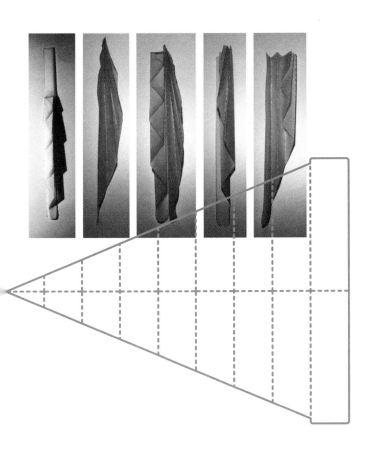

analysis_ diagonally pleated dress

textile techniques_ folding, layering, change of direction
transformation_ multiple shift, variation in scope and proportionality,
mutual dependence
materiality_ transparent paper
effects_ volumetric spatial variation, expansion, compression

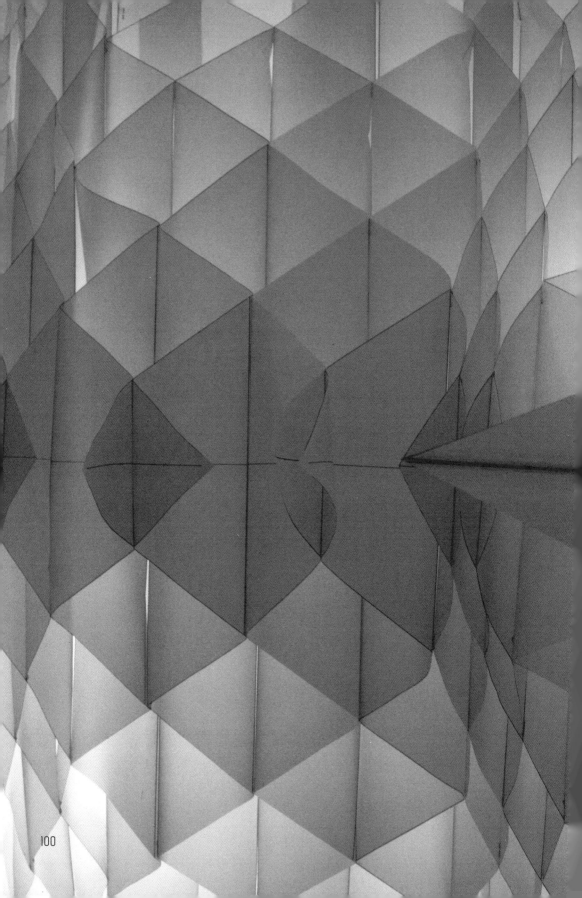

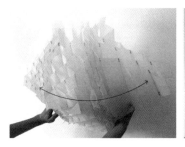 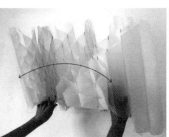 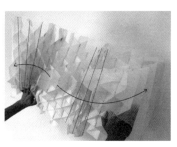

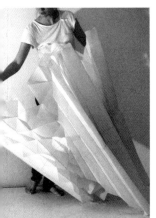
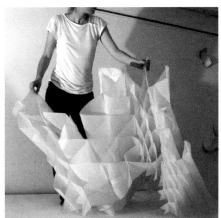
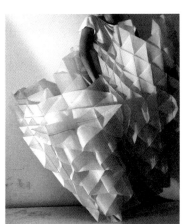

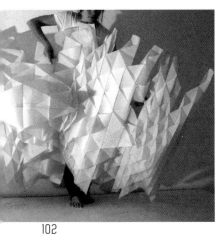
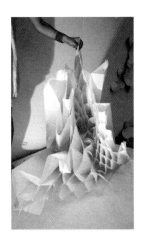

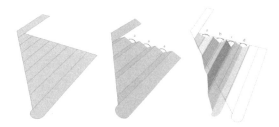

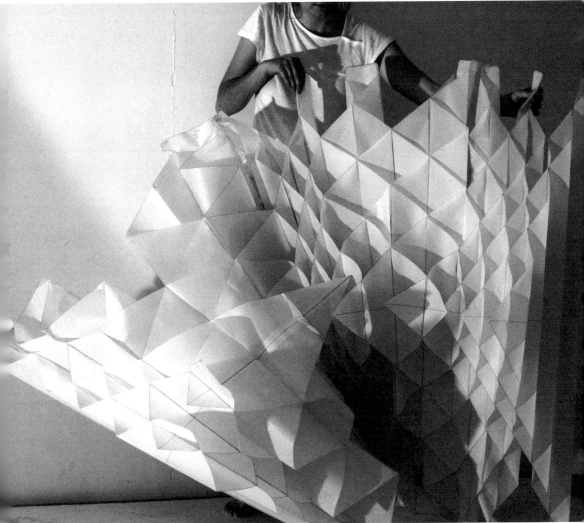

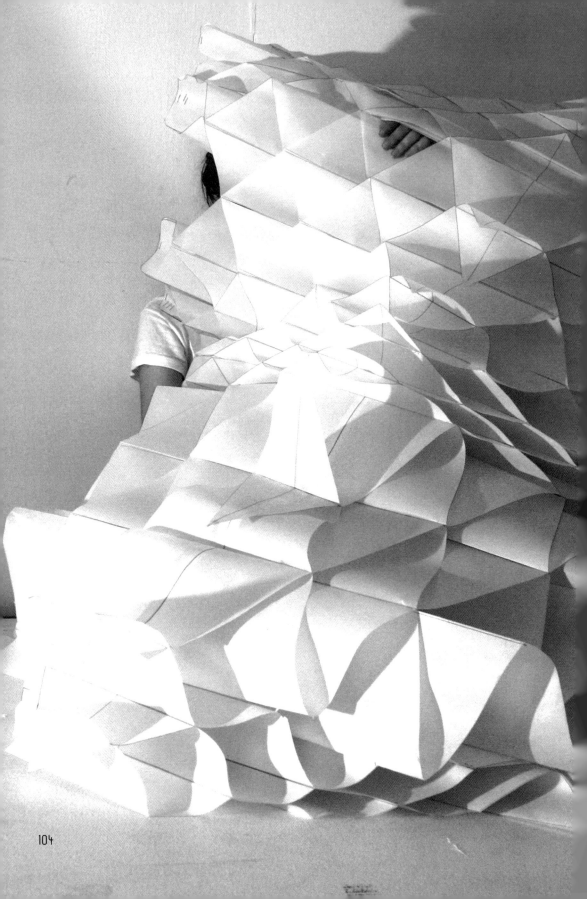

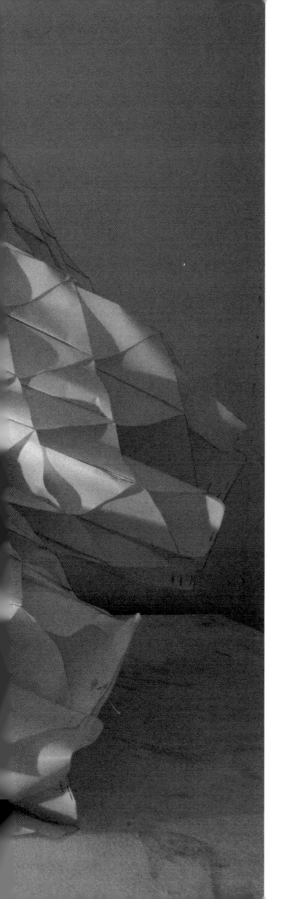

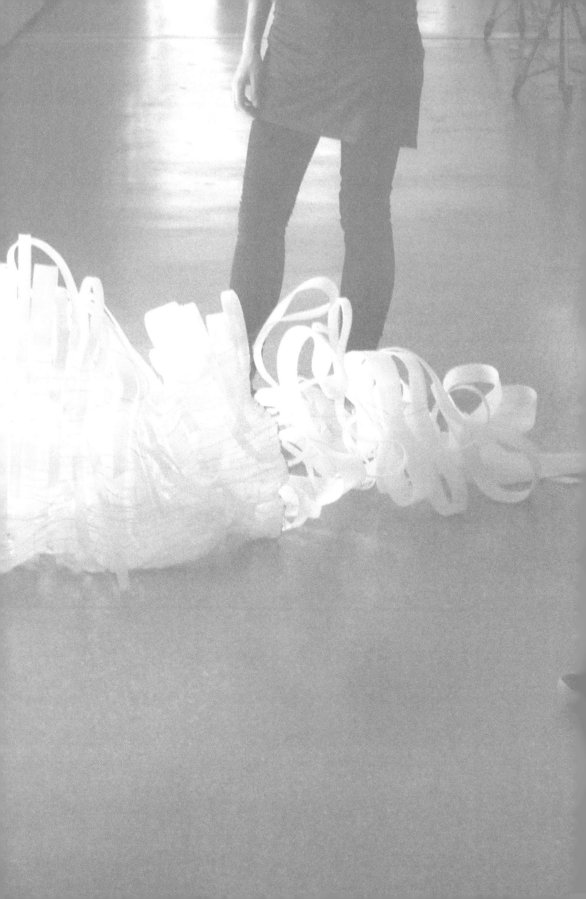

There is a design discourse where all these morphogenetic experiments acquire a certain symbolic capital. The conceptual network that partially defines the current architectural avant-garde resembles a loosely plaited structure itself, interwoven around the notions of surface, ornament, patterns, parametricism and the performative, in which apparently novel concepts responding primarily to the specificity of the digital medium are constantly converging. In this context the notion of textile – though far from being novel- can become extremely relevant. Motivated by the results of this workshop I would like to revamp the notion, revisiting elements of Semper's theory and redefine the term exemplifying the textile as a relativistic device that encompasses both surface and ornament, generates patterns, and alludes to the performative as a responsive system.

methodological shifts
the textile as retro-novel paradigm
by Sophia Vyzoviti

Cut-Stretch, Optical filter by Sophia Vyzoviti

Besides the general assessment, the textile as a retro-novel paradigm is a conceptual tool to address the experiments presented in this publication. It is intrinsic to the objectives of the particular workshop in that it has submitted a set of fashion products as precedent cases for analysis and a set of textile techniques as operational tools. It is also a means to relate to form generation principles pertinent to the current discussions on morphogenesis. In their majority, the formal characteristics of the objects presented display topological surface transformations through folds, wraps, torsions, incisions, loops and knots. They attain curviliniarity and maintain continuity. Partial and whole relationships are regulated either by subdivisions of a continuous surface or by assemblies of elementary continuous surface units varying in size. The set comprises an archive of surface primitives where the objects themselves can be considered as patterns containing information about their making. This information is conveyed parametrically, not in absolute measurements but as sets of relations and proportions, disciplined in time sequences of transformations.

The objects presented are simultaneously abstract and concrete. They constitute a spectacular display of form studies in soft and elastic material displaying elementary tectonic techniques such as weaving and joining. Their primary tectonic characteristics derived from surface divisions and assemblies are also their ornaments: series and arrays of cuts, pleats, and knots. Within their ambiguity regarding specific design end product these surface primitives – or should we say primitive surfaces – provide primary covering and enclosure conditions. Primary in their tectonic substance and primary in their space defining capacity they are all primarily wearable and spatially explored through the human body.

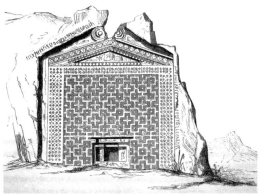

Tomb of Midas, source: Gottfried Semper, Style in the Technical and Tectonic Arts; Or, Practical Aesthetics

We are therefore confronted with artefacts of a primary craft – the textile. According to Gottfried Semper the textile precedes, informs, and later becomes consolidated into architecture. Structural and ornamental characteristics of tectonics (carpentry) and stereotomy (masonry) originate in the craft of textiles. As exemplified in the first of his two volumes study Style in the Technical and Tectonic Arts; Or, Practical Aesthetics, the textile is the earliest artistic technique. Its essence is 'a system of material units whose attributes are pliability, suppleness, and toughness' whose basic objectives are '1. to string and to bind; 2. to cover, to protect, to enclose.'

So what are the novel characteristics of these retro-novel textiles? Basically they operate as conceptual constructs for architectural form finding that are accomplished in analogue media in correspondence with the essential principles of digital morphogenesis. Therefore they are pertinent to the current debate and can at the very least be appreciated as material diagrams.

They literally manifest the opportunity inherent in digital design for an animate architectural body because they maintain kinetic behaviour by permeability and flexing. Animated here by the human body rather than parametric sets of digital modifiers these surfaces become performative; they are engaged with and respond to interior and environmental settings.

We are presented with a topological ballet performing a hybrid choreography. Oscillating between Oskar Schlemmer's Slat Dance and Luie Fuller's Dance Serpentine, these surface primitives are not costumes that "enclothe". They instead become figures in themselves when set in motion by the dancers, choreographed automata constrained by their intrinsic structural-ornamental characteristics. In this hybrid dance the subject that emerges is the surface, a soft, malleable, ephemeral form supported by a stylized, rigid, and therefore neutralized human body: an interactive hollow body construction.

Perhaps the most valuable contribution of these experimental design processes, besides our aesthetic pleasure in their results, is the opportunity to speculate on a new constitution of the architectural object. In this case emulating its origin in the animate textile a soft and malleable, light and flexible, kinetic architectural object is emerging.

To conclude, I would like to quote Kenneth Frampton on Semper's Theory of Formal Beauty. The reference locates the extreme relevance of Semper in this provisional treatment and is absolutely contemporary:

"He would no longer classify architecture with painting and sculpture as a plastic art but rather with dance and music as a cosmic art, as an ontological, world making art evocative of nature in action rather than as the static substance of two-and three dimensional form".

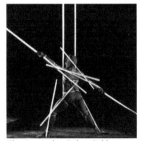

Slat Dance by Oskar Schlemmer

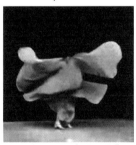

Dance Serpentine by Luie Fuller

Cut-Stretch,study in plexiglass by Sophia Vyzoviti

Optical filter facade of ,cut' hair salon in Larisa Greece by matrix_g.sea: Elina Karanastasi and Sophia Vyzoviti, www.matrixgsea.blogspot.com

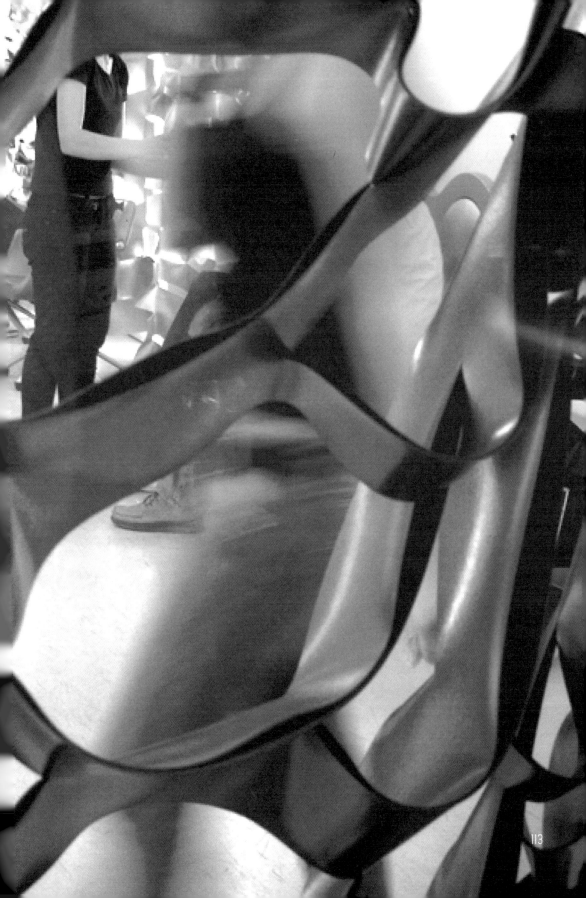

analysis_ handmade layered dress by Helena Hörstedt

textile techniques_ folding, layering, interlinking
transformation_ re-combination of layered loops
by changing their spatial orientation
materiality_ colored PVC foil
effects_ spatial layering, translucency, reflection

interconnective loops

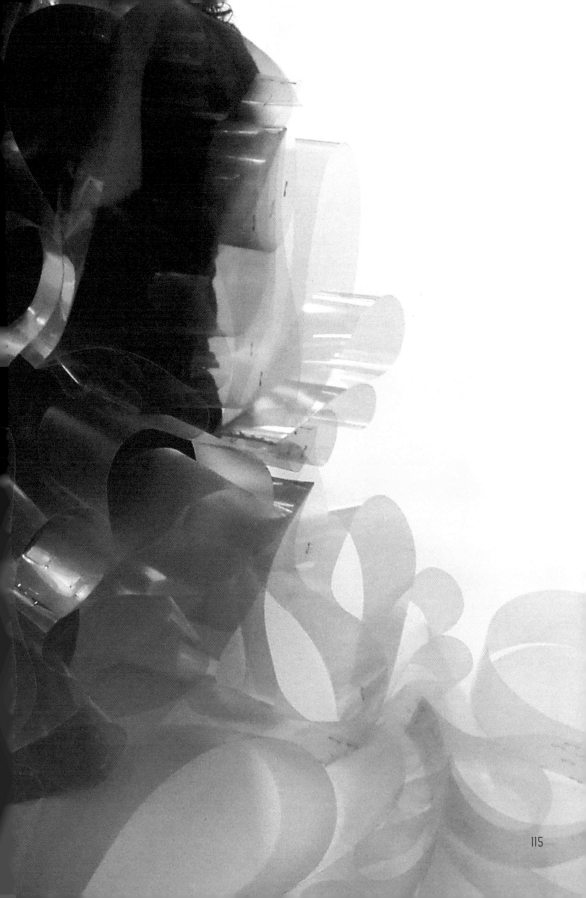

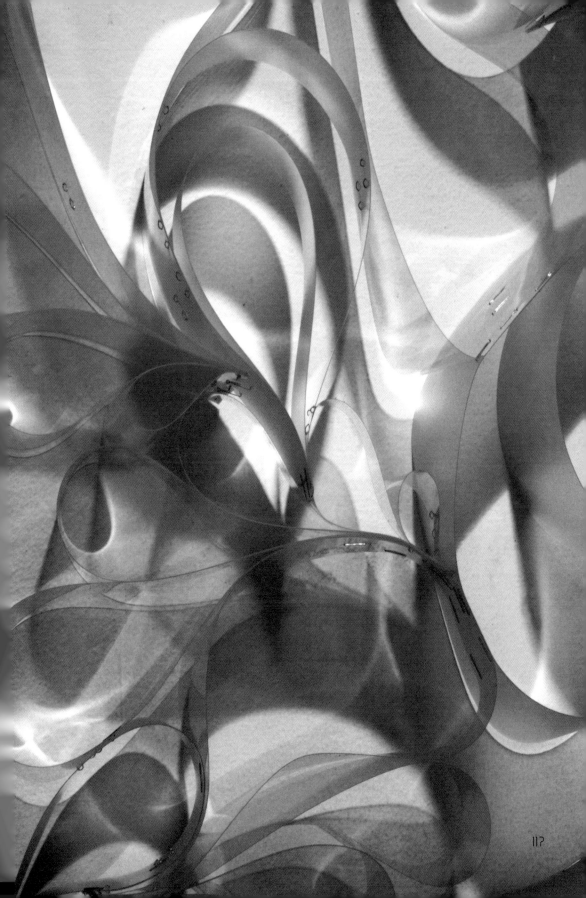

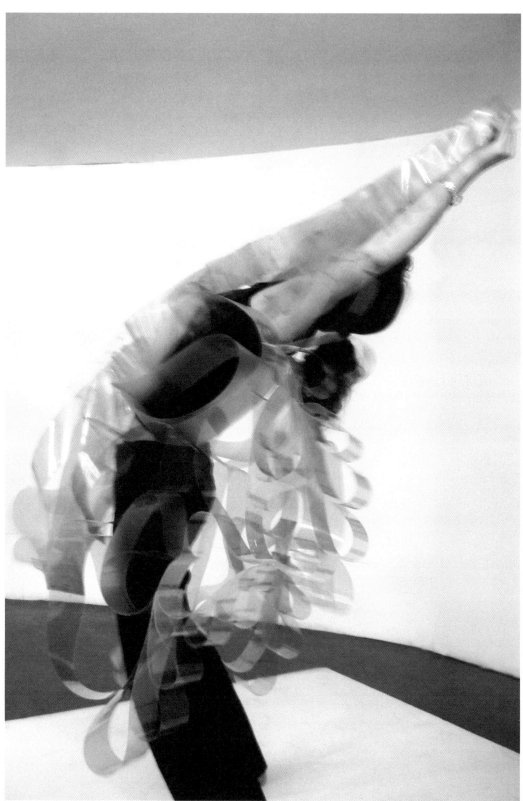

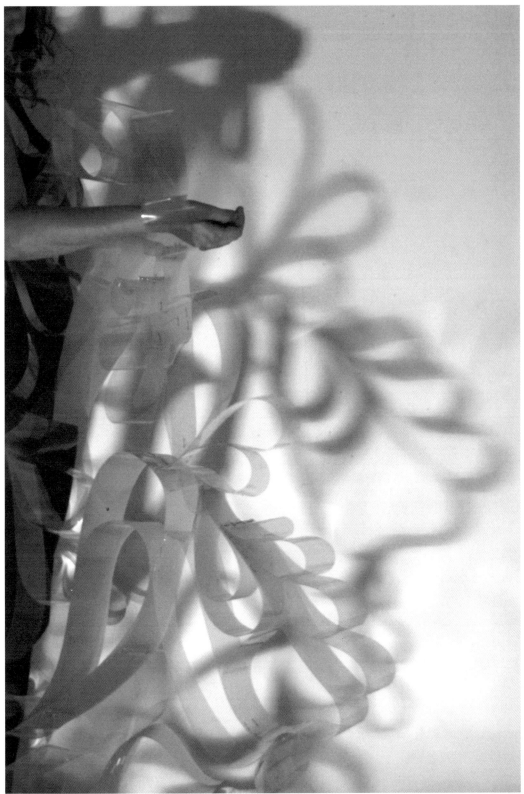

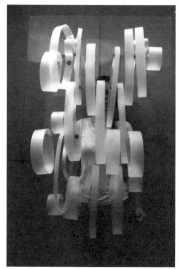 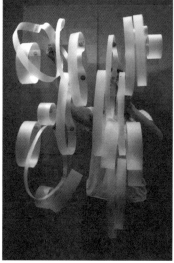 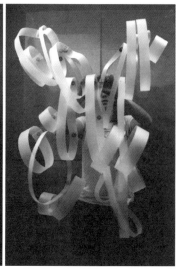

sliding interrelations

analysis_ multiple-pleated dress by Issey Miyake

textile techniques_ looping, connecting
transformation_ development of a system that changes its density by
shifting the relations of its elements
materiality_ Plexiglas, foil, buttons
effects_ shifting spatial relations, density, blurring of boundaries

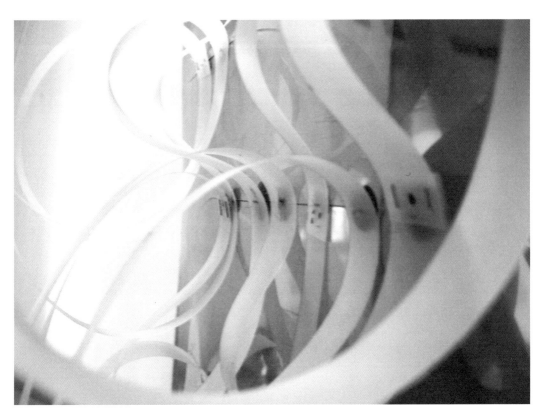

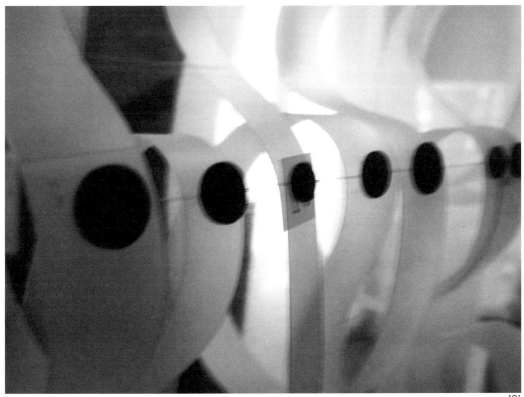

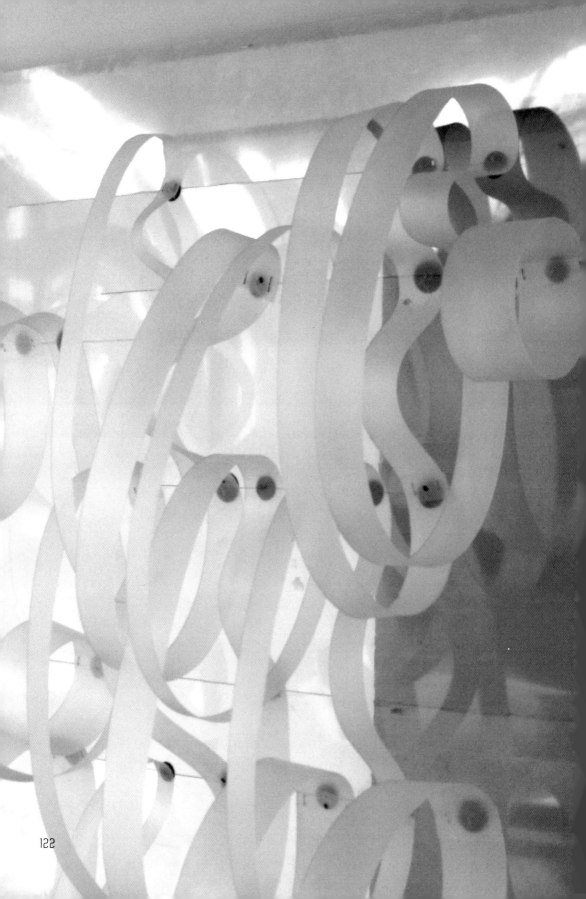

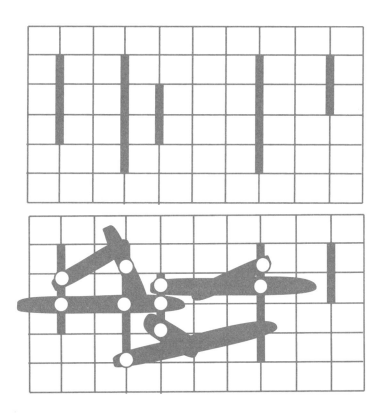

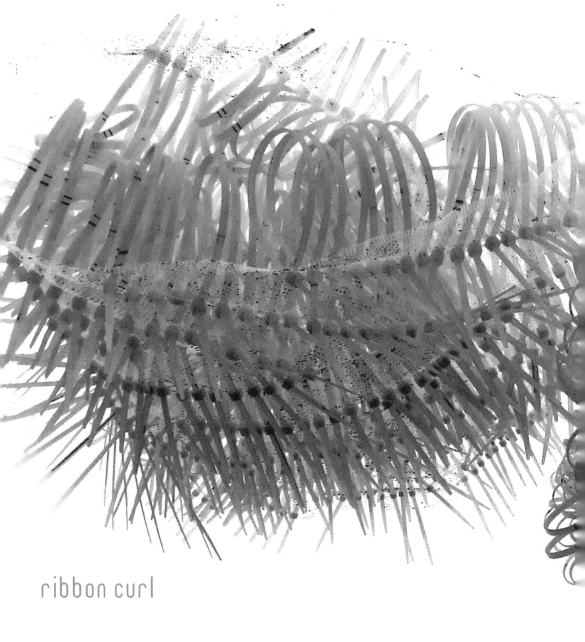

ribbon curl

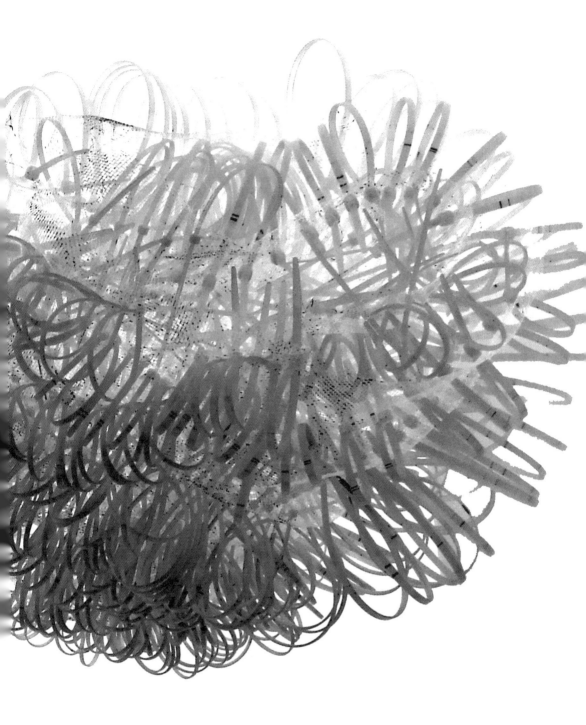

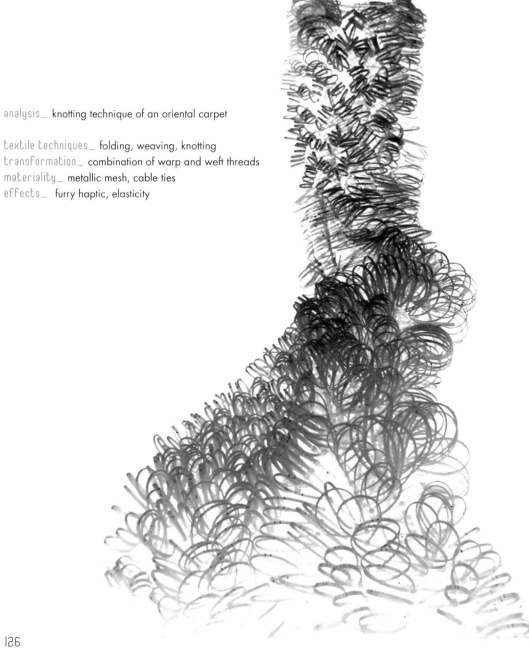

analysis_ knotting technique of an oriental carpet

textile techniques_ folding, weaving, knotting
transformation_ combination of warp and weft threads
materiality_ metallic mesh, cable ties
effects_ furry haptic, elasticity

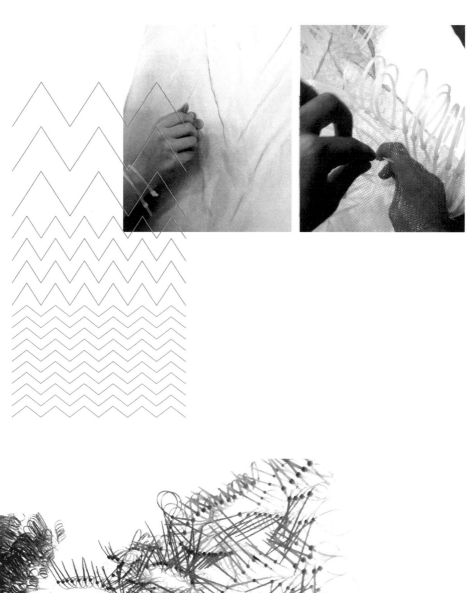

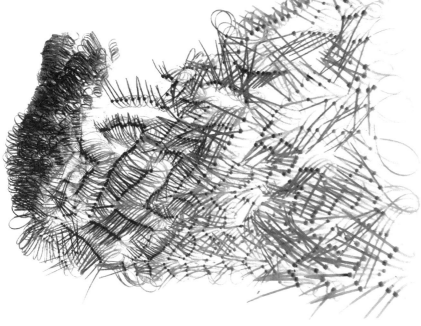

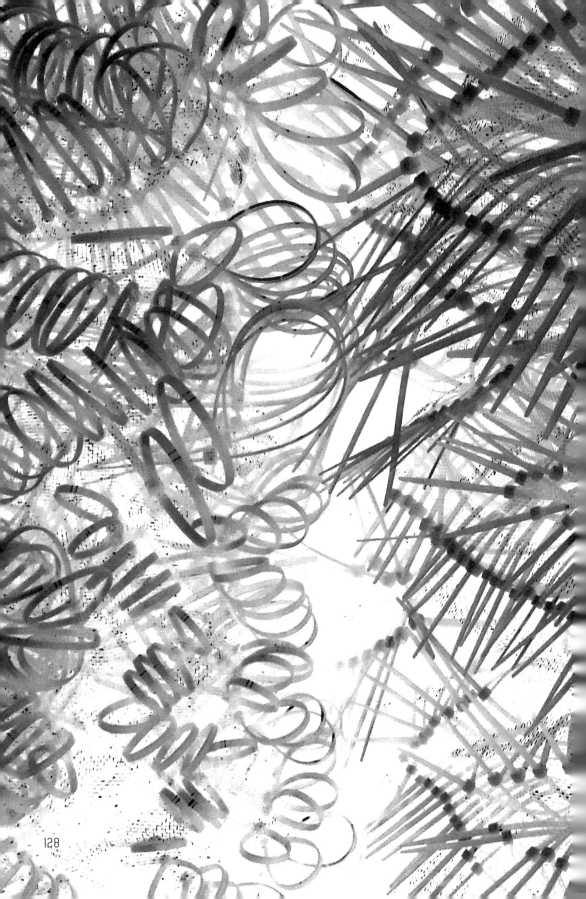

128

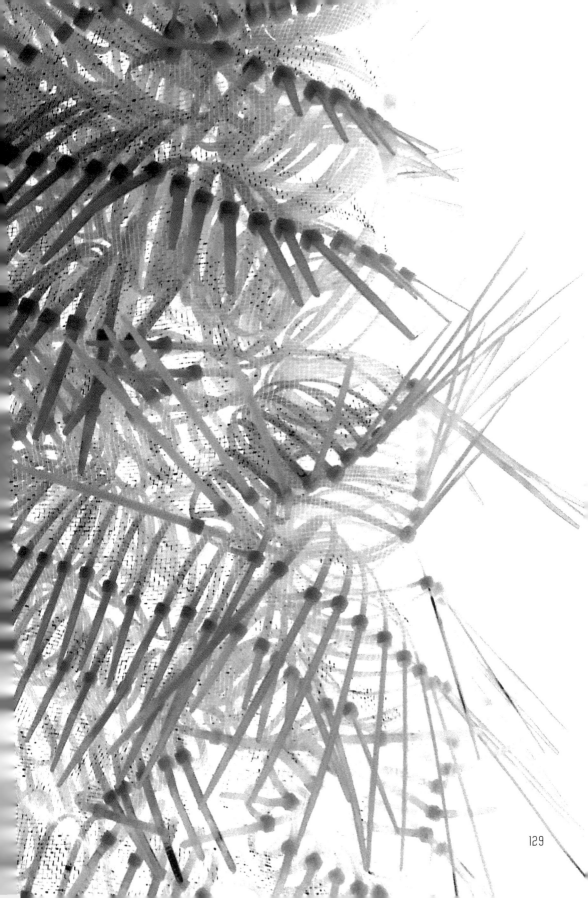

129

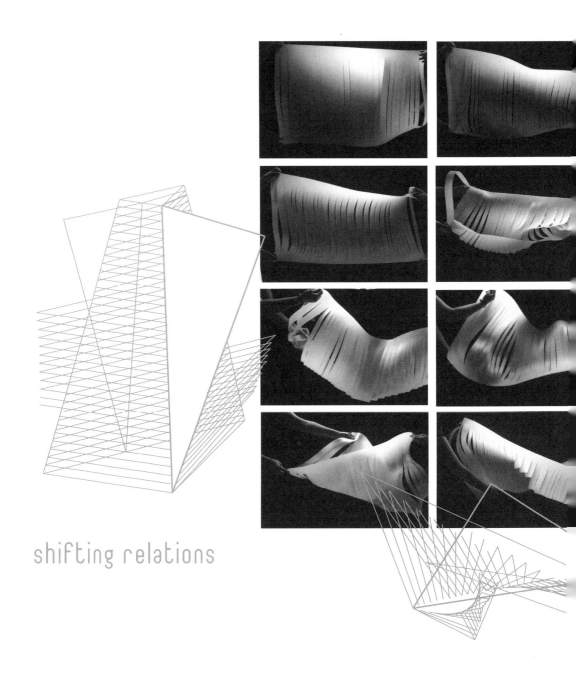

shifting relations

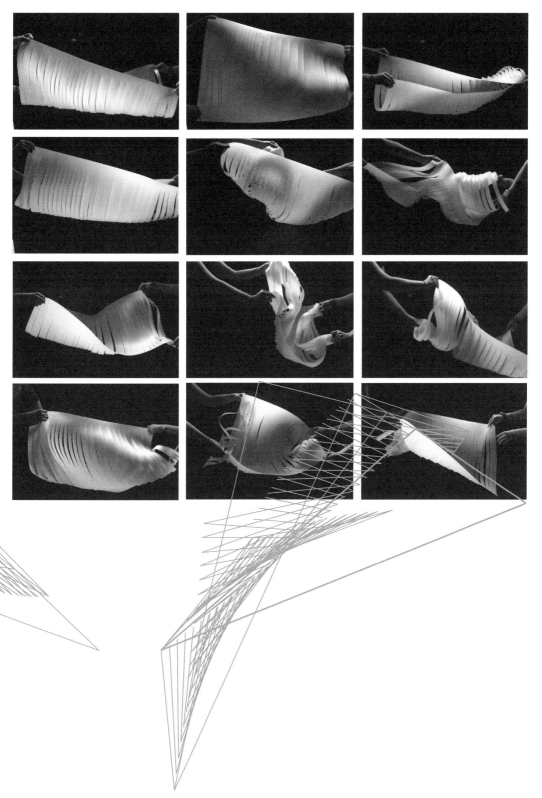

131

analysis_ folded paper skirt

textile techniques_ cutting, folding, bending
transformation_ dissolution of a double-layered surface into connected stripes
materiality_ paper, cardboard in various thicknesses
effects_ twisted space, density, blurring of spatial boundaries

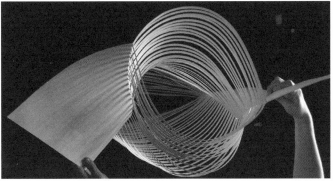
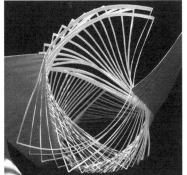

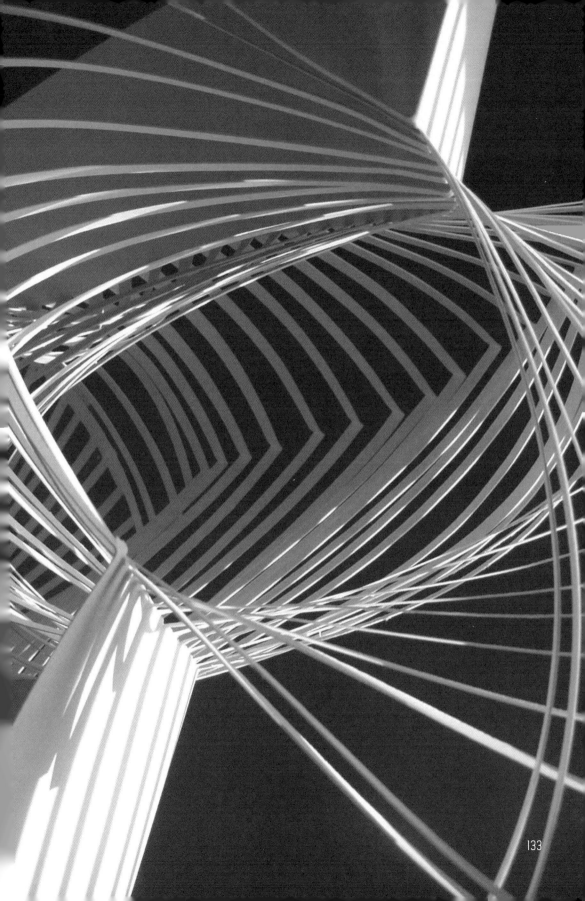

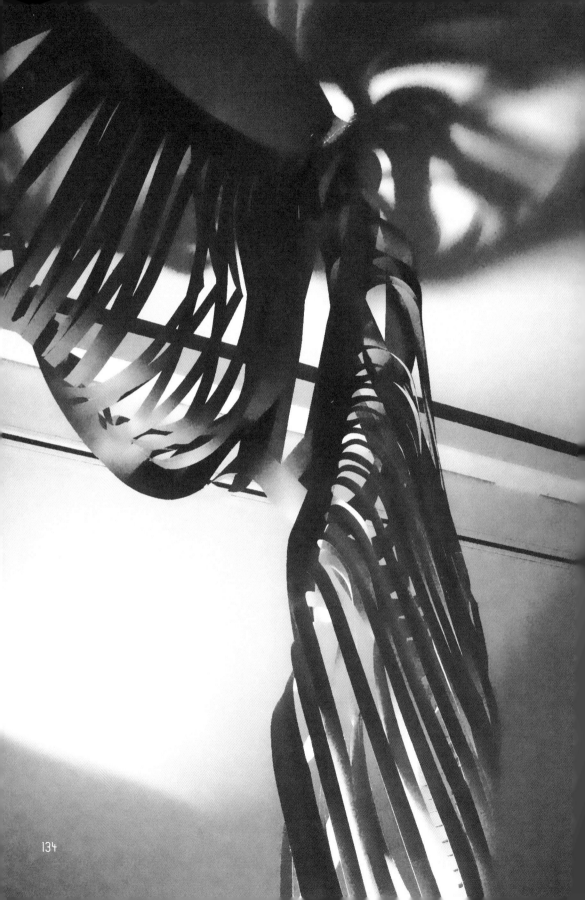

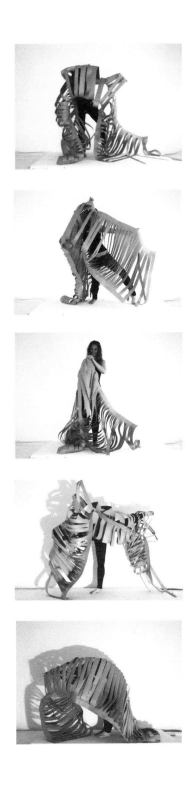

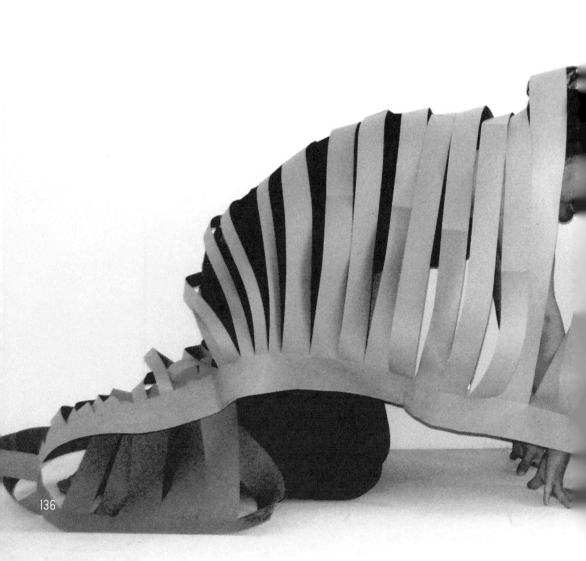

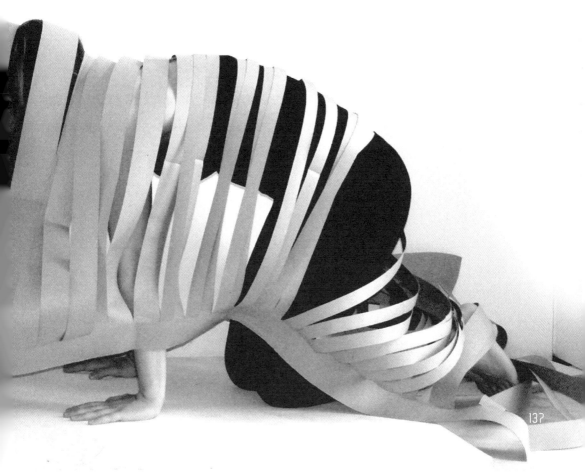

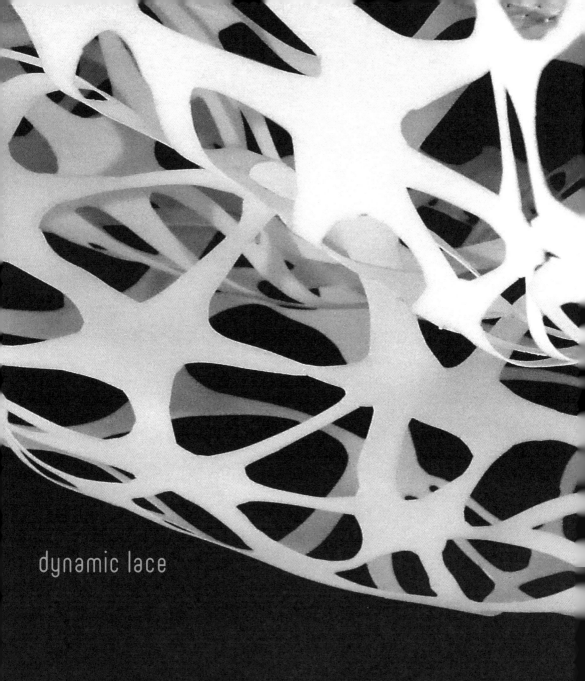

dynamic lace

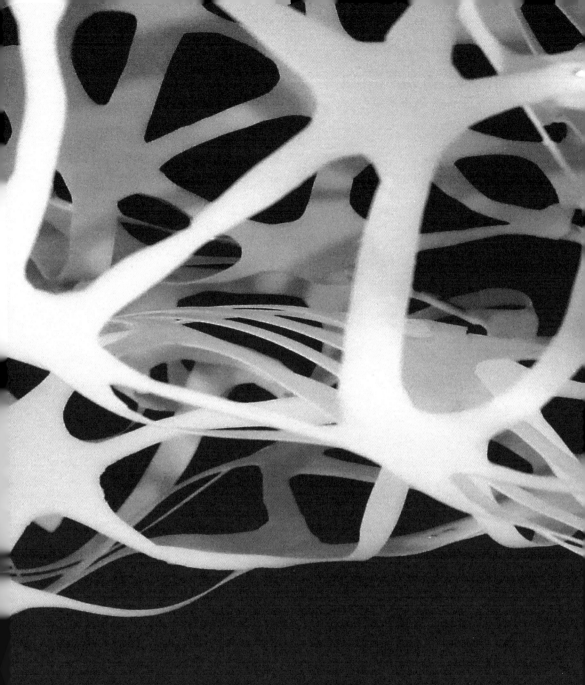

analysis_ laser-cut fabrics by Elena Manferdini

textile techniques_ cutting, thermoforming
transformation_ multi-layered surface, punctually connected
materiality_ PVC sheets
effects_ porosity, layering, deep surface

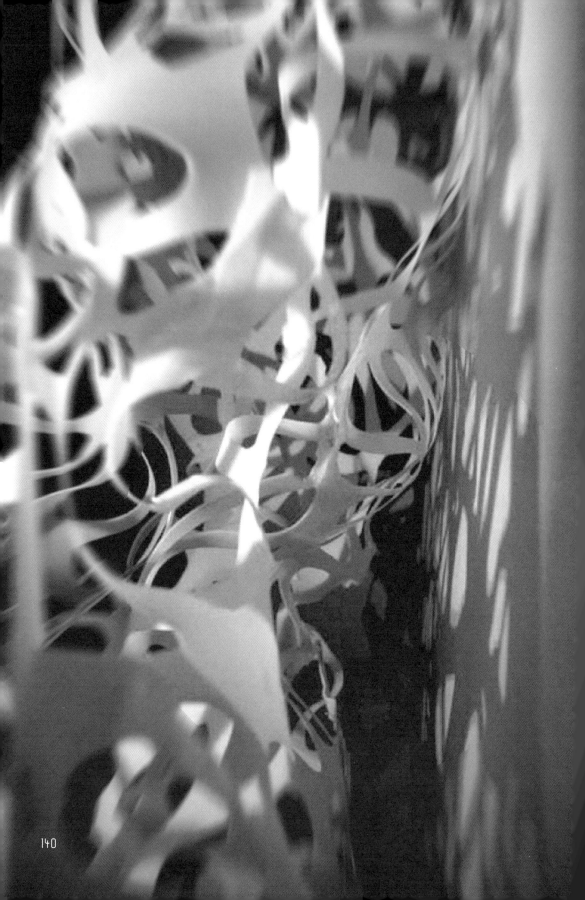

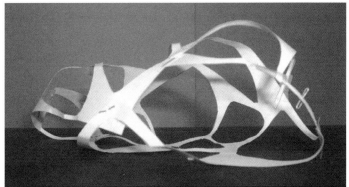

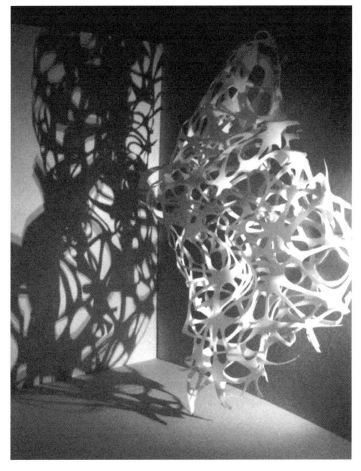

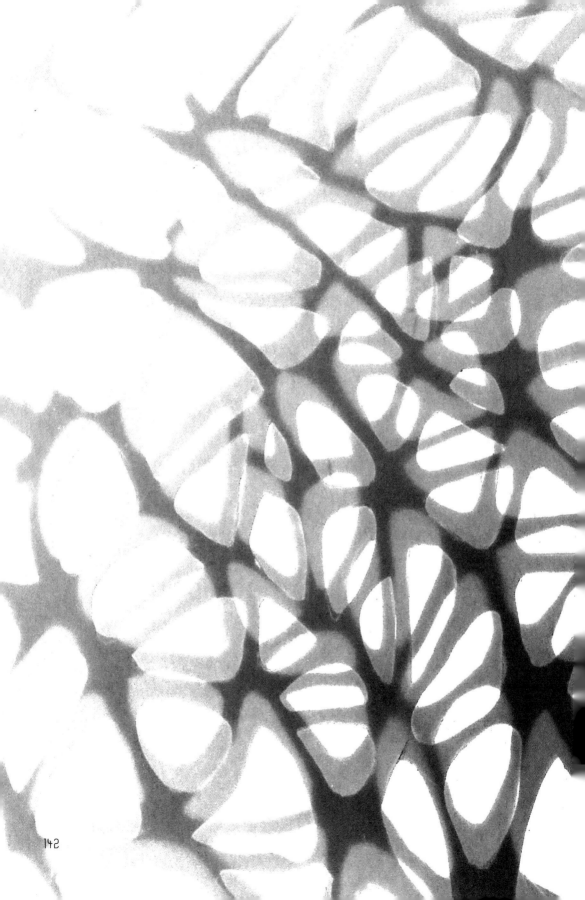

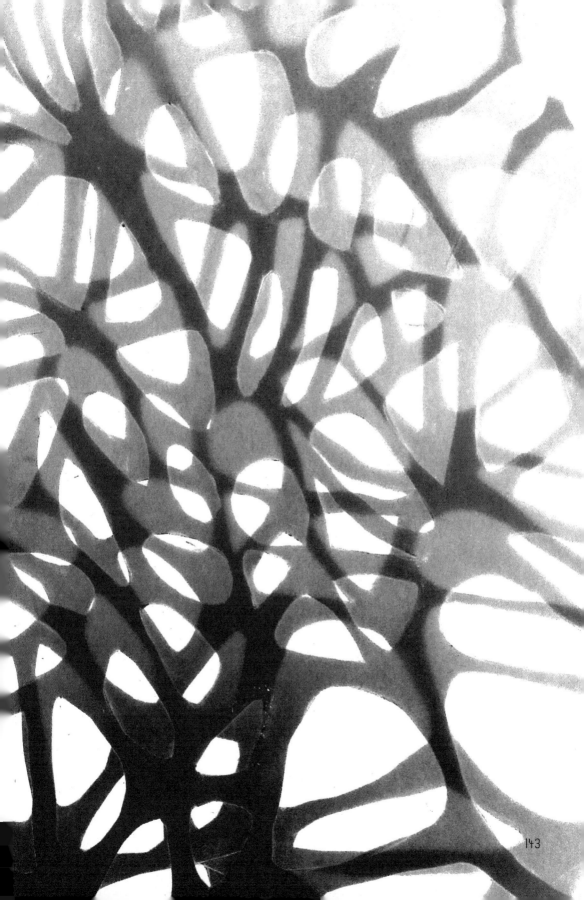

143

epilog

The definition of form in an architectural design process has never been an accidental matter. Even at its worst, creation of form is influenced by various parameters and elements. The design environment, the media used, the material, the climate, the construction law, the construction cost and the constellation of the design team are some of the elements which, consciously or subconsciously, play an important role in the production of form.

In the last years the role of the computer as a medium of design and production is constantly gaining importance. Numerous new digital form finding tools, methodologies and manufacturing processes are dominating the architectural design practice, threatening to eliminate physical form finding and modelling techniques.

analog-digital designing processes

by Asterios Agkathidis

CAD / CAM designed and produced canopy in Frankfurt by Just.Burgeff Architekten and Asterios Agkathidis

It is indeed a fact that the emerging CAD/CAM technologies are opening new exciting possibilities in architectural planning and construction processes. The architects seem to achieve the greatest precision ever, flexibility and determination of the planning process. But can analogue designing and modelling techniques really be replaced by digital media without at the same time causing a significant loss of architectural and spatial qualities? Can these apparently contrary design approaches eventually be combined and in that way enrich the design process with different inputs?

Algorithmic Chair by Asterios Agkathidis, Kyriakos Chatsiparaskeuas, Matthias Knöpfel, Andreas Schmatz

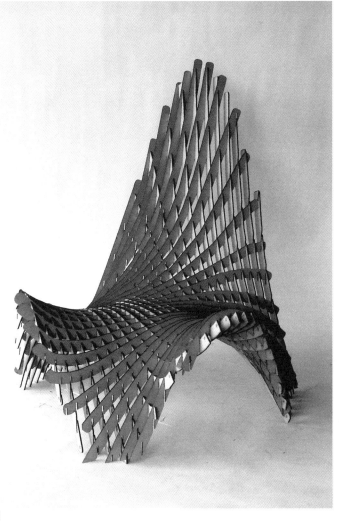

Today, the main discussion of digital design approaches is based on parameterization and scripting tools, techniques which are migrating from computer sciences into architecture. They transform the role of the architect to that of an overall programmer and coordinator, able to iterate and optimize design with algorithm based applications. The key to such an iterative – self generative design process is the ability of the digital tools to handle enormous amounts of data, running in a flow of model generations, treated in a circular procedure. In that way, a large number of design decisions can easily be tested and pre-selected.

Through parameterization of design components, the developed geometry is able to re-adjust itself to certain predefined parameters, set by the designer. Digital geometry can thus become intelligent. In addition all kinds of physical simulations can practically replace any type of physical design environment until the final realization phase. Even there, the designed structural elements can be directly delivered to the CNC manufacturer, represent in a "soup to nuts" digital approach. The architect seems to gain total control from design to production. But does this absolutely parameterized process automatically mean a better architecture?

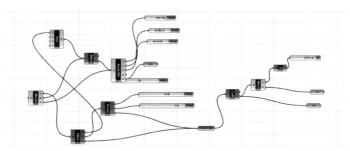

Grasshopper script as digital parametrization tool, by Asterios Agkathidis

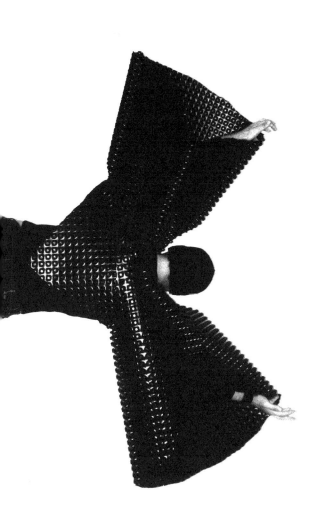

wearable - performable device by
Alexander Berg and Anton Matvicuk
(body-tecture workhop, FH Bielefeld)

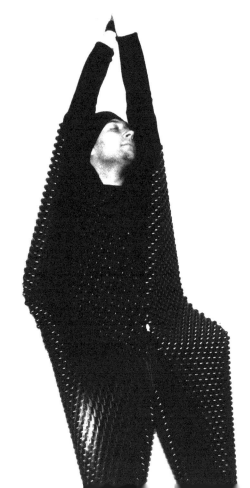

In the examples shown in this book we are expressing our belief that analogue design and modelling techniques can offer an alternative to the digital approach described above. In the "performative geometries" workshop held in the Aristotle University of Thessaloniki during the summer semester of 2009, geometrical, physical and material components used in fashion design were used as primary mechanisms for spatial exploration.

Each student group started by analyzing clothes designed by renowned designers, trying to explore the spatial and material effects occurring by making or wearing textiles. They were later asked to transform the analyzed components in new spatial – material systems, able to be performed, experienced and explored with their own bodies. It is the human scale, which seems to be almost forgotten in design and education processes.

During a physical approach, material properties, friction and gravity were always present. They set the primary framework for form definition. The introduction of the 1:1 wearable or performable prototypes allowed a new discourse between space, material, lighting and shadow and the direct experience of performance.

The human body plays an essential role here. It introduces a cinematic - choreographic process of geometrical manipulation, able to produce a large variety of spatial effects and qualities. Bodies and materials are merging in a combined system, which operates as generator of space detail and texture. The fascination of these bodily animated systems is their ability to focus on the stage of becoming, not the stage of finalization. They don't pretend to be results ready to be applied to an architectural project. They function as precursors of the architecture: a shape, a detail, a typology or, a plan.

Nevertheless, the direct physical experience introduces the notion of the unexpected, the surprise of the mistake, the unpredictable, which hardly occurs in a digital procedure. A mistake could kill the digital algorithmic procedure and must be eliminated. Here it could offer new chances, and unpredictable effects.

The examples shown here are inducements to question the dogmatism of contemporary digital design tendencies in architectural education and practice. In fact, these apparently "different" methods of design may not be so different in their essentials after all. If based on the same conceptual platform, in interplay analogue – digital designing and modelling techniques can reinform and complement each other. Joint venture instead of digital monotony. Analogue aesthetics via digital settings.

biographies

Asterios Agkathidis

Asterios (born 1974) studied architecture in the Aristotle Univ. of Thessaloniki, the RWTH (Aachen) and the Staedelschule (Frankfurt). He was a partner in the architectural practice b&k+ (Cologne, 2001- 04), and then worked for VMX architects (Amsterdam) until 2005. He founded the architecture and research laboratory *a3lab* Frankfurt - Thessaloniki, in the same year. Since then he has been practicing architecture and design publishing, exhibiting, winning prizes and realizing projects throughout Europe. Teaching and lecturing experiences include AdbK Nuremberg, TU Darmstadt, the Univ. of Thessaloniki, the Univ. of Bielefeld, the Columbia Univ. and the Staedelschule. He is currently visiting Professor in the LAU. In 2010 he published his 4th book, *Digital Manufacturing*, distributed internationally by BIS Publishers Amsterdam.

Aleka Alexopoulou

Aleka Alexopoulou (born 1951) studied architecture in Aristotle Univ. of Thessaloniki and the College of Art/Herriot-Watt Univ. in Edinburgh. She is Associate Professor in architectural design in the School of Architecture, Faculty of Engineering, A.U.Thessaloniki. She has been practicing architecture since 1975 ,designing mainly buildings and public spaces, taking part in architectural competitions.

Sasa Lada

Sasa Lada (born 1946) studied architecture at the Aristotle Univ. of Thessaloniki (1969) and in MARU (1972-73) in London Univ. Today she is Professor of Architectural Design and Director of the Architectural Design and Fine Arts Department in the School of Architecture, AUTH. Sasa is an architectural designer, researcher and writer. Her teaching and research interests have focused, mainly on the architecture of public space and buildings. She was co-founder and principal architect of the architectural office METE-SYSM in Thessaloniki. Her architectural projects have won architectural competitions and have been published in many architectural magazines. Through individual and collective research projects her work over the past ten years has explored various interdisciplinary intersections between feminist theory and architectural theory and design. Her last book is *Gender, Diversity and Urban Space* (2009) (in Greek).

Rouli Lecatsa

Rouli (born 1953) completed her architectural studies in the HdBK Hamburg in 1978. After establishing her own practice in Athens (1978-81), she received the R. Lodderstiftung Scholarship in Berlin (1982). She then returned to Hamburg where she cofounded the gallery for architecture design and art, *Möbel-perdu*. In 1987 Rouli founded the *Atelier for Architecture and Design*, whose success continues today. Her teaching experience includes the HdBK Hamburg and in the Univ. of Applied Sciences in Bielefeld, where she is currently professor for design and architectural theory.

George Papakostas

George Papakostas (born 1949) is Professor of Architectural Design and Head of the School of Architecture of the Aristotle Univ. of Thessaloniki. He has been scientific associate in the Institute for Lightweight Structures at the Univ. of Stuttgart (IL) obtaining the title of "Spezialist fuer Leichte Flaechentragwerke". He has been a visiting researcher at the Pratt Institute and visiting professor at the Royal School of Architecture Copenhagen. His professional activity includes more than 110 architectural design projects and architectural competitions including the B' biennale of young artists of Mediterranean countries installation project, the municipal theatre of Kalamaria - Thessaloniki, the civic theatre of Thessaloniki 'Theatro Kipou', and the expansion of the Thessaloniki Airport. His architectural research includes 32 scientific articles published in Greece and abroad, and his architectural work is published in 66 Greek and international architectural bulletins.

Gabi Schillig

Gabi Schillig (born 1977) studied architecture in Coburg and at the Staedelschule in Frankfurt. She worked for several architectural studios in Berlin, Sydney, Frankfurt and Coburg before establishing her own research and artistic practice in Berlin. She teaches at the Berlin Univ. of the Arts / Institute for Transmedia Design and has lectured and taught internationally in the Staedelschule Frankfurt, Internationale Sommerakademie Salzburg, TU Braunschweig, Aristotle Univ. Thessaloniki, Columbia Univ. among others. Gabi has received numerous fellowships - amongst others, fellowships at Akademie Schloss Solitude, Stuttgart, Van Alen Institute, New York and the Nordic Artists' Centre in Dalsåsen, Norway. *Mediating Space. soft geometries – textile structures – body architecture*, a monograph catalogue of her recent work has been published by merz & solitude in 2009. Her work has been exhibited in Frankfurt, Stuttgart, Berlin, London and New York.

Sophia Vyzoviti

Sophia Vyzoviti (born 1971) studied architecture at the Aristotle University of Thessaloniki, Greece, the Berlage Institute and the Delft Univ. of Technology in the Netherlands, where she completed her PhD in 2005. She has taught architectural design at Delft University of Technology, the National Univ. of Singapore and the Univ. of Thessaly, Greece, where she is currently assistant professor. She has practiced as an architect in the Netherlands and is founding member of *matrix_g. sea architects* based in Thessaloniki. She is author of the books *Folding architecture: spatial, structural and organizational diagrams* (2003) and *Supersurfaces: Folding as a method of generating forms for architecture*, products and fashion (2006) distributed internationally by BIS Publishers Amsterdam.

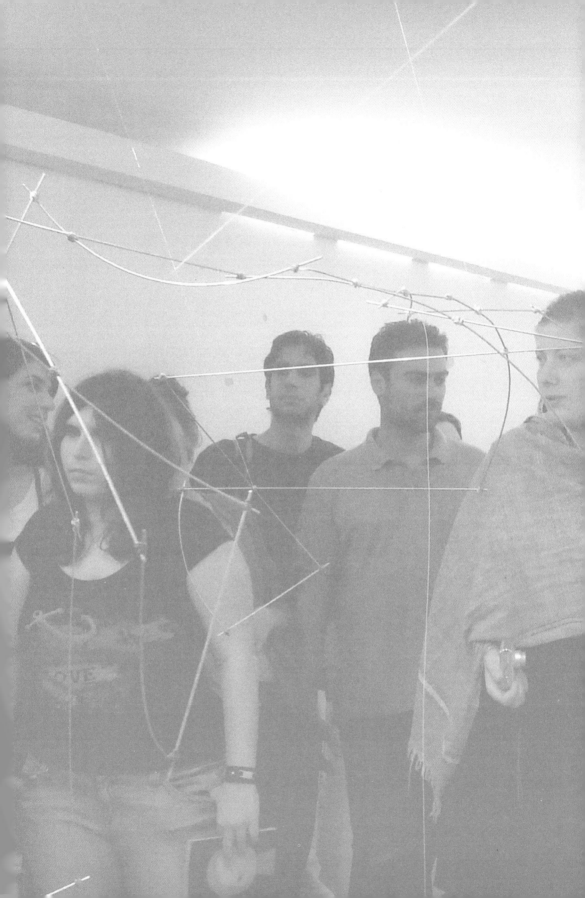

credits

editors

Asterios Agkathidis | Gabi Schillig

Aristotle University Thessaloniki
Faculty of Architecture
Studio Transitional Spaces
Sasa Lada
Aleka Alexopoulou

publisher

BIS Publishers
Building Het Sieraad
Postjesweg 1
1057 DT Amsterdam
The Netherlands
T +31 (0)20 515 02 30
F +31 (0)20 515 02 39
bis@bispublishers.nl
www.bispublishers.nl

authors/essays

Asterios Agkathidis
Aleka Alexopoulou
Sasa Lada
Rouli Lecatsa
George Papakostas
Gabi Schillig
Sophia Vyzoviti

project credits

receptive knot
Ifiyenia Dimitrakou
Sandy Karagkouni
folded stripe
Dinora Chatzisavva
Domna Katsani
skins & bones
Marianna Kazakou
Stella Papazoglou
woven mesh
Alexis Bolarakis
Daphne Papaemanouil
skinesis
Savina Dardelakou
Fani Manoutsopoulou
Chryssa Varna
reaktor
George Mavridis
Michael Velenis
animated linearity
Dimitris Chatzopoulos
Nikos Karagiannis
laced cluster
Adriani Charalambous
Eirini-Xrisobalanto Sotiriou
stratified envelope
Plavou Vasiliki Maria
Smouklis Fotis
rotational centers
Konstantina Iakovou
Fani Ntintoka
graded formations
Sofia Avramopoulou
Parina Vasilopoulou
Giannis Koseloglou
interconnective loops
Lina Manaroli
Aigli Papakyriakou
Penny Semertzidou
sliding interrelations
Paraskevi Chatzidimitriou
Emmanouil Pallas
ribbon curl
Paraskevi Fanou
Alkmini Petraki
Maria Vlagoidou
shifting relations
Athina Georgopoulou
Anthi Skoupra
Sofia Tsagkera
dynamic lace
Eleutheria Florou
Antonia Sdoukopoulou
Zafeiroula Simopoulou

photo credits

Asterios Agkathidis | Gabi Schillig |
workshop participants

p. 08-11 © All images of Hélio Oiticica´s work are courtesy of Projeto Hélio Oiticica,
Rio de Janeiro

The authors are responsible for obtaining permission to reproduce all images. Every
reasonable effort has been made by the editors to contact/locate the copyright own-
ers. Additional information brought to the publishers attention will appear in future
editions.

proof reading

Geoffrey Steinherz

graphic design

Asterios Agkathidis | Gabi Schillig

isbn

978 90 6369 250 6

year

2010

information

www.arch.auth.gr
www.a3lab.org
www.gabischillig.de